# CHURCHES OF OXFORDSHIRE

NICOLA COLDSTREAM

AMBERLEY

*To the clergy and churchwardens of Oxfordshire*

This edition first published 2023

Amberley Publishing
The Hill, Stroud
Gloucestershire GL5 4EP

www.amberley-books.com

British Library Cataloguing in Publication Data.
A catalogue record for this book is available from the British Library.

ISBN 978 1 3981 0768 7 (print)
ISBN 978 1 3981 0769 4 (ebook)

Typesetting by SJmagic DESIGN SERVICES, India.
Printed in Great Britain.

# CONTENTS

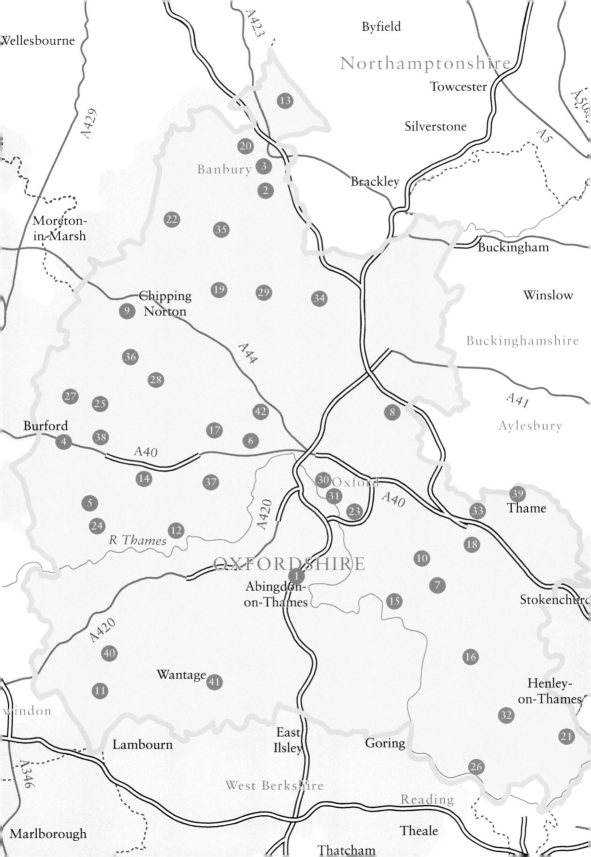

# Introduction

Oxfordshire, once part of the Anglo-Saxon kingdom of Mercia, has always been a wealthy county. Watered by the River Cherwell at the east and the Thames with its many tributaries to the west, which formerly defined the county boundary, the land supports both arable farming and animal husbandry, historically famous for sheep. The landscapes vary from the chalk and beechwood Chiltern Hills in the south to the limestone uplands of the Cotswolds in the north and west, while east of Oxford stretches the flat, secretive world of Otmoor. In 1974 the county boundary was extended westwards to take in part of Berkshire, which has added chalk downlands and towns and villages in the region of the upper Thames.

Building materials vary as much as the landscape. While brick was often used in the south of the county, further north the builders took advantage of the great belt of oolitic limestone that runs from Somerset up into Yorkshire, curving through Oxfordshire on its way. Especially around Burford and Chipping Norton it yields very fine building stone of a creamy-grey whiteness that is highly characteristic and was widely used outside the area. Further north and east the limestone becomes ironstone, which was quarried not only for its iron ores but for the beautiful golden and brown stone that we see from Great Tew northwards.

All this is reflected in the varied church buildings. Their architecture is not necessarily grand, but it is handsome and atmospheric. This book looks at a small, representative selection of buildings and their contents – some proudly in towns, others settled into their rural landscapes. Since church buildings were almost always modified over the centuries, many that date from the Middle Ages are apt to contain features from several periods. Some have been chosen because they still show their Anglo-Saxon origins, some are here for their surviving wall paintings and some for remarkable tombs that reflect the efforts of their occupants to commemorate their fortunes and the family name. From later centuries we have some fine seventeenth- and eighteenth-century interiors, work by leading architects of Gothic Revival, the Arts and Crafts movement and a church built in the 1990s.

Church interiors can be dark and details that are high up can be difficult to make out. Binoculars and a powerful torch are always useful.

## 1. St Helen's Church, Abingdon

Abingdon stands at the confluence of the rivers Thames and Ock, the former being crossed by an early fifteenth-century bridge. Medieval Abingdon was dominated by its powerful abbey, and the extraordinary parish church, in the heart of the old town, can be seen as an assertion of identity by the townspeople, its tower and tall spire (last rebuilt in 1888) dominating the view from across the river. Inside the church is one of the finest medieval panel paintings in Britain.

The entrance is through the thirteenth-century tower to the north side of the church, which opens into a series of aisles, five in all, making the building's north–south axis wider than the liturgical east–west one. Four of the aisles date from the fifteenth century, and the southernmost from the sixteenth, for which money was bequeathed by Katherine Audlett to commemorate her husband. There are no transepts, the east wall is flat, and the chancel and Lady chapel delineated by screens. The handsome moulded arcades are supported on octagonal columns with moulded capitals with eight concave sides (a form otherwise found in some Gloucestershire 'wool' churches) and surmounted by a simple clerestory. The later arcade varies in detail but honours the earlier ones.

The glory of Abingdon is the wooden ceiling of the Lady chapel, at the east end of the second aisle. Made *c*. 1390, it consists of a series of blind panels set against openwork screens, as if a rood screen has been lifted and tilted. The apex is a longitudinal panel of openwork lozenges cut with featherlike tracery. A long inscription runs along each side. The panels are ogee-headed, divided into two 'windows' with red backgrounds. Each contains standing figures representing the lineage of Christ: a Tree of Jesse, with kings of the House of David and prophets. From the (now lost) image of Jesse in the south-east corner runs a continuous painted vine scroll upon which the figures stand. A few of the images have been destroyed, but the survivors are of the highest possible quality. The conservation by Anna Hulbert in the 1980s revealed their

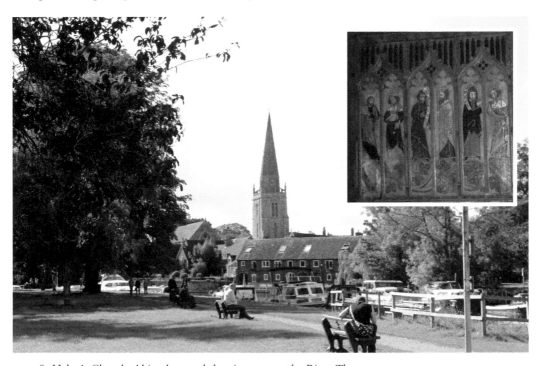

St Helen's Church, Abingdon, and the view across the River Thames.

*Inset*: Detail of the painted ceiling of the Lady chapel.

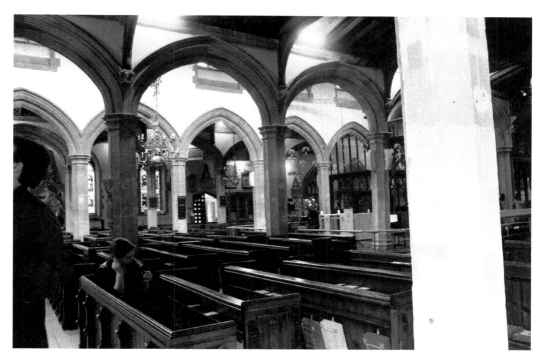

Interior, looking north-east.

elongated, slightly sinuous forms, each individualised, the kings wearing coronets and the prophets the elaborate contemporary hats by which they were distinguished in medieval iconographic tradition. The kings carry sceptres, the prophets scrolls, and each is identified by inscription below the panels. Faces are highlighted, eyes and noses delicately touched in. Hair is wild and corkscrewed. The hems and sleeves of the draperies are edged in white, giving the figures extra definition.

In any church without paintings such as these, the nineteenth-century stained glass in St Helen's would be much noted, and it should not be missed here. On the west wall at the fourth aisle is a modest brass memorial to Geoffrey Barbour, merchant (d. 1417), who paid for the building of the town bridge.

## 2. ST MARY'S CHURCH, ADDERBURY

Adderbury's church is partly built of the golden ironstone familiar in the Banbury area and, like its neighbours at Bloxham and King's Sutton, boasts a fine spire. It was these three that the architect of **Over Worton** church may have sought to emulate. St Mary's, Adderbury, is a large building for a village church, cruciform, with a chapel-like chancel, transepts and nave with very wide aisles. It developed incrementally with additions and replacements, and, having fallen badly into decay by the late eighteenth century, was carefully restored by two architects who were both steeped in the study of medieval architecture. The chancel was put back together by J. C. Buckler in 1831–34 and the nave and transepts by George Gilbert

Scott in 1866–70. The most obvious sign of their work is in the window tracery, much of which is theirs, based on scrutiny of the surviving evidence.

The church's thirteenth-century beginnings are best seen in the transepts, although they were remodelled around 1340 when the nave aisles and the west tower were built. The nave arcade has chamfered arches on octagonal piers with moulded capitals. At the ends of the aisles are two figured capitals: one showing the heads of women, the other knights with linked arms. These must be related to similar capitals at **Hanwell**, which gives a clue to the extraordinary display of sculpture on the outside of both aisles. Recently conserved, these sculptures are of outstanding quality with friezes of heads, mythical beasts and musicians, evidently by the masons who produced similar work at Bloxham, Hanwell and Alkerton. Among the mythical creatures are a mermaid and several curious creatures that were believed to occupy the edges of the world beyond everyday experience; there are musicians playing a hurdy-gurdy, drums and a pipe organ; and monsters have elaborately twisted tails. Much mythology surrounds the interpretation of figures such as these, but the likeliest is that some have an apotropaic function, to ward off evil, and others are simply there for the fun of it.

With the chancel we enter a different world. Adderbury belonged to the bishops of Winchester, and in the late fourteenth century Bishop William of Wykeham, founder of New College, Oxford, gave the parish to his new foundation. The chancel was rebuilt by New College in 1408–19, partly under the direction of Richard Winchcombe, a master mason who did much work for the college. Built

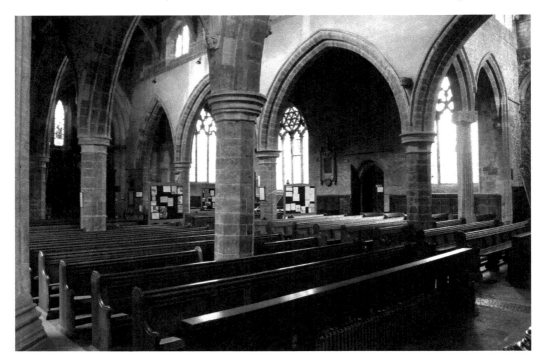

Nave of St Mary's Church, Adderbury, looking north-west.

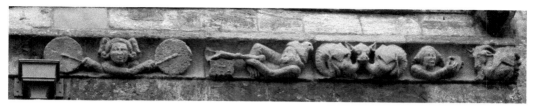

Exterior frieze, north side detail.

of the paler, greyish Taynton stone, the chancel is tall, rectangular and lit by huge windows, their present tracery designed as academically as possible by Buckler. It is a light-filled Perpendicular space that feels much like a college chapel, managing to be both grand and intimate. By the early fifteenth century Perpendicular had settled into a style of repetitive, panelled surface decoration, the same designs used for wall surface, windows and over empty spaces. At its best it is a style of delicate and lucid tranquillity, and it is certainly at its best here.

## 3. ST MARY'S CHURCH, BANBURY

This northern corner of Oxfordshire has several very interesting churches. I have selected three, all within a few miles of each other: Banbury, **Hanwell** and **Cropredy**.

St Mary's, at the top of Horsefair, is engulfed in mature trees, so what you see from a distance is its cylindrical west tower, which at once signals that this is not a medieval building. The present church was begun in the 1790s to replace its large medieval predecessor, which had been declared ruinous. The architect was Samuel Pepys Cockerell (d. 1827), who planned a large square, perhaps based on the footprint of the earlier church, but surmounted by a large shallow dome. An apse with rooms for the clergy is at the east, and at the west the shallow semicircular porch is flanked by staircases that lead up to the capacious galleries. Although on plan the twelve piers seem to form a square, the vaults are configured to suggest that the dome is supported on an octagon, which harks back to Sir Christopher Wren's churches in the City of London, buildings well known to Cockerell. Consecrated unfinished in 1797, the church had to wait for completion under Cockerell's son Charles twenty years later. The final ensemble of portico surmounted by a cylindrical tower owes much to Charles.

As we see it now the interior is carefully painted in a rather successful mixture of colours; the Ionic capitals, a Venetian red picked out in gold, are striking. As befitted the eighteenth century the church was intended to be a preaching box, but it was transformed from the 1860s through the forceful intervention of the Bishop of Oxford, Sam Wilberforce, the vicar Henry Back and the architect Arthur Blomfield. All three were members of the High Church Oxford Movement, determined to bring the sacraments and the altar back into focus: Wilberforce and Blomfield also played a major role at **St Barnabas in Oxford**. Blomfield raised the level of the choir and installed the paintings round the apse, in a reference to such surviving early Christian churches as San Clemente in Rome. Blomfield's choir was effectively removed in the 1960s, but the paintings, done by Heaton, Butler

and Bayne to imitate mosaic, are still there: Christ sits in Majesty in the apse with the symbol of the evangelists, and the Apostles are in the panels beneath, set in groups in delicate treescapes.

The stained-glass windows are part of the 1860s scheme. Best seen from the galleries, they are very fine work by Alfred Hassam, who died in 1869 aged only twenty-six, already a master of his craft. They illustrate the life and Resurrection of Christ, and the parables, each set in a roundel contained within a square (possibly reflecting the plan of the church). The spaces are filled with exquisite foliate motifs, and the colours and slightly abstract handling of the figures might well remind you of such fine practitioners as William Morris and Edward Burne Jones.

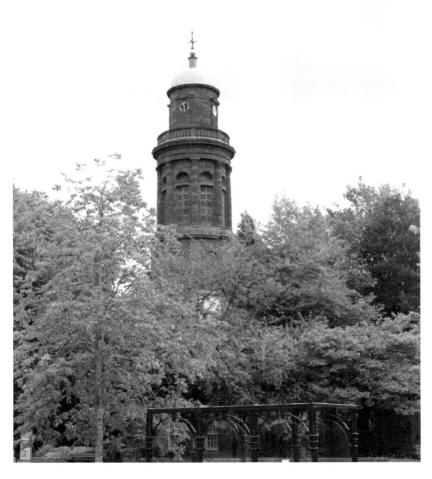

St Mary's
Church tower,
Banbury.

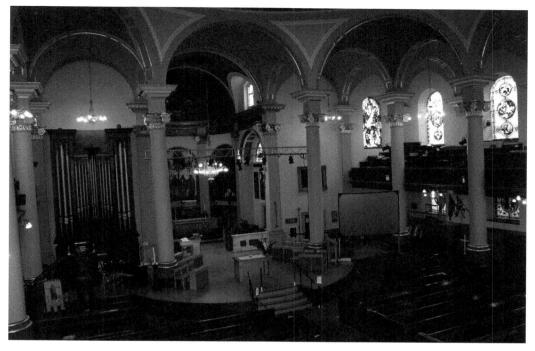

Interior, looking east from the gallery.

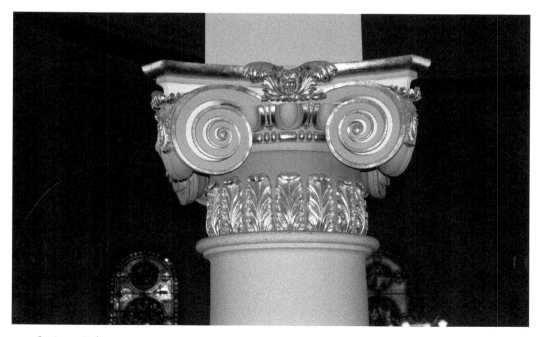

Ionic capital.

## 4. QUAKER MEETING HOUSE, BURFORD

The Quakers had arrived in Burford by 1683. They built their meeting house in stages from the first decade of the eighteenth century. It is a delightful small building in the pale creamy-grey stone from the famous limestone quarries at Taynton, a short distance westwards up the Windrush Valley. The half-hipped roof is of Stonesfield slate, which is both highly prized and local. The meeting house consists of one large ground-floor room lit by tall sash windows either side of the entrance door, a gallery around two sides and a top room under the roof, lit by windows in the gables. Various offices were added at the back in 1981. Although the building was closed at times owing to a decline in numbers, it has been in use again since 1955, and despite changes of ownership between times the interior of the main room is unaltered, except for the removal of an elders' gallery.

The gallery is supported on square timber posts, and the gallery, wall panelling and wooden floor show signs of the simplest and least-fussy methods of construction. Adze marks can be seen, and the floorboards are laid side by side rather than tongue-and-grooved. The top room has a rafter roof with collars and longitudinal purlins, all fairly crudely hacked. The lower purlins, which act as the wall plate, look as if they have been reused from some previous function.

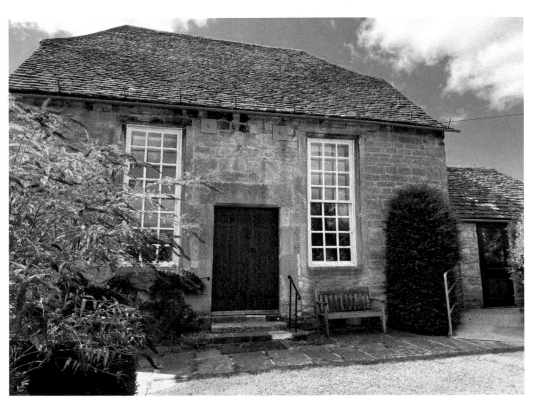

Exterior of Burford's Quaker Meeting House.

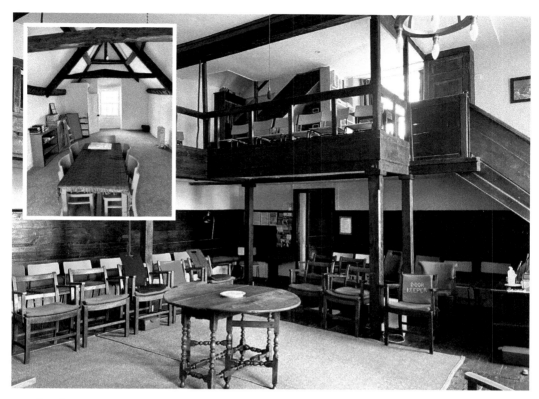

Interior.

*Inset*: Top room.

## 5. St John the Evangelist Church, Carterton

Oxfordshire has very few churches built after the nineteenth century; Carterton's is one of them. As well as having an interesting design, it has an interesting history. The parish has kept a detailed archive of the church's development, so that for once we can see not only its architectural evolution but the involvement of the parish community.

Carterton was founded as a new village a few miles south of Burford and Witney in 1900. The first church arrived as a prefabricated structure in 1911, as a chapelry of the nearby parish of Black Bourton. Known as 'the Tin Hut', it survived until 1963, when the expansion of the village, close to the RAF base at Brize Norton, led to a new parish of Carterton and Brize Norton and the need for a larger building. Carterton continued to grow, becoming the second-largest town in west Oxfordshire. In 1963, J. M. Surman was commissioned to design a new building: Hall-Church, a lofty rectangular building without aisles, which supplied parish needs until the 1990s, when a larger building was needed once again.

This new building, by Peter Gilbert-Scott, was begun in 1993, and is an exceptionally clever design, both practically and psychologically. He wrapped his structure around two sides of the Hall-Church, which was left intact and can be seen above the entrance to the new building. West of the Hall-Church and opening out of it, Gilbert-Scott created an enormous square with sides of 15 metres, topped by a lantern and lit by large windows at the corners and small ones high on the sides. Built of cream-washed rendered blocks on a stone plinth, the church sits on the main north–south road through the town, its hip-roofed lantern rising above the lean-to roofs of the square, which has shallow gabled projections. Two polygonal single-storey pavilions flank the entrance on the north side.

The harmonious exterior proportions are echoed on the interior – a space that has a feel of unhurried purpose. The cable-tensioned roof floats above your head on a steel frame, leaving the ground level free of obstacles. The Hall-Church, open to the east, adds to the impression of spaciousness. A pleasant nod to Carterton's medieval neighbours, notably Brize Norton, which has fine Norman sculpture, is the cross-rib under the roof of the lantern – charming, but structurally unnecessary. Owing to the survival of the Hall-Church, the altar is now at the west end of the building. All the furnishings, including the font, were brought out of the Hall-Church; at the original east end only the altar hanging remains in place.

Continuity has been essential to Christian practice from the beginning, and here we see it in action. The parishioners were involved in all stages of the building and its decoration; for example, the Jesus hanging on the south wall was made in 1999/2000 by Valerie Payne-Morris, who embroidered the parishioners' signatures in panels around the sides.

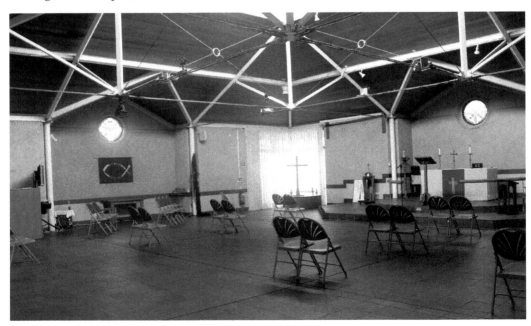

Interior of the new St John the Evangelist Church, Carterton.

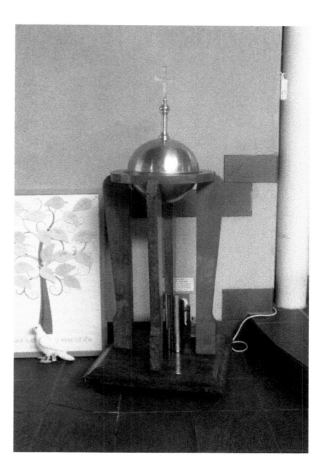

Font.

## 6. ST PETER'S CHURCH, CASSINGTON

The tall, early fourteenth-century spire of St Peter's, one of the best in the county, is visible from a distance, but the church tends to disappear as you come nearer, hidden by trees in the old village, which is now engulfed in new housing to serve commuters to Oxford. The spire, however, is no indicator of date: the great surprise is that this is essentially a Norman church, of very high quality and charm.

Built in the 1120s by Sir Geoffrey de Clinton, Treasurer to Henry I, the church is built of limestone rubble with ashlar facings and corners. The aisleless nave and small chancel are separated by the bay that supports the central tower and spire. One decorated archway leads from the nave and a second similar one opens from the other side of the tower bay into the chancel. Almost identical, they are a lesson in Anglo-Norman decoration: the big roll-mouldings on the arches descend to plain cushion capitals supported on columns tucked into the angles of the jambs. Over the top runs a moulding decorated with shallow chevrons. The cushion capitals may well have been painted with foliage or

animal ornament, but nothing now remains. The chancel bay is vaulted with heavy rolled cross-ribs.

Norman windows survive in the chancel and the exterior is decorated at roof level and on the tower with a lively, if decaying, corbel table – rows of heads under the eaves, mostly of monsters and fantastic beasts. It was probably the Montagu family, lords of the manor in the early fourteenth century, who raised the tower and spire and updated many of the windows to the fashionable Decorated style, including the flowing leaf pattern of the west window.

The rood screen at the entrance to the chancel dates to around 1500, and the south porch, with a splendid timber roof, must be of approximately the same date. The extensive collection of stained-glass fragments in the nave windows is as mysterious as that at nearby **Yarnton**; some of it possibly comes from the same source. None is original to this church, but it has certainly found a good home at Cassington.

Although the church was restored in 1876–77, the parishioners were able to keep the ancient pews, which probably date to the fifteenth century and have plain but moulded ends – solid workmanship that holds its presence in the building.

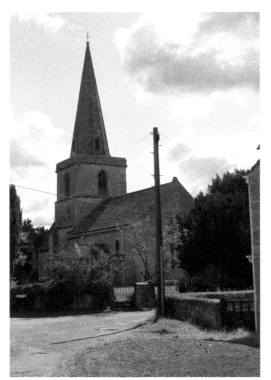 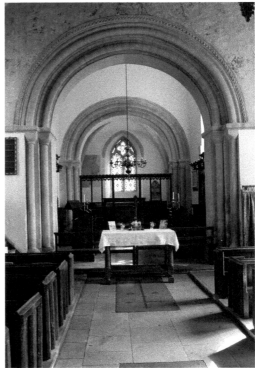

*Above left*: Exterior of St Peter's Church, Cassington, from the west.

*Above right*: Interior, looking east.

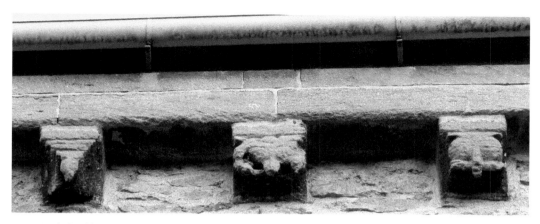

Corbel table, nave south side.

## 7. ST MARY'S CHURCH, CHALGROVE

Chalgrove church is rightly famous for the cycles of wall paintings that cover the chancel walls. The chancel was rebuilt in the years around 1320, when Chalgrove had been given to Thame Abbey by Edward II, with requests for monks to pray for the souls of the king and Piers Gaveston. Not surprisingly, it is architecturally very smart, with reticulated tracery in the windows and a set of sedilia (seats for

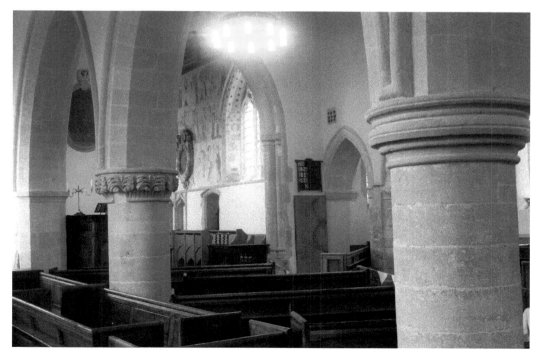

Nave and chancel interior of St Mary's Church, Chalgrove.

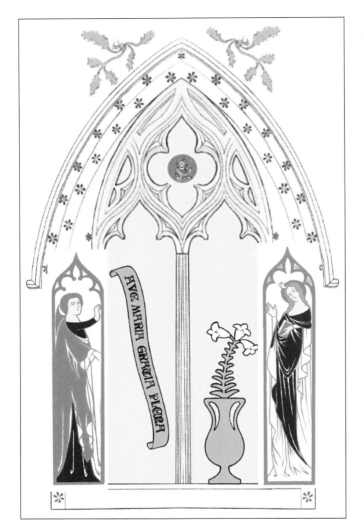

*Above left*: Annunciation scene. (Reconstruction by Robert Heath-Whyte, Madeleine Katkov and John Cook, © *St Mary's PCC* Chalgrove)

*Above right*: The Virgin Annunciate. (Photo James Brennan Associates, © *St Mary's PCC* Chalgrove)

the clergy) under ogee-headed arches. The paintings were evidently done at the same time, and in the floor are memorial brasses to the Barentin family, who were powerful local landowners. It is rare to find a surviving example of a building and its original decorative programme, and this one is of very high quality, probably reflecting its royal connections.

   The paintings, fugitive but expertly conserved by Madeleine Katkov, illustrate the infancy and Passion of Christ on the north wall and the death and Assumption

of his mother, the Virgin Mary, on the south wall. Excellent guidebooks and leaflets in the church help you to elucidate the individual subjects in a narrative that is traditional but very carefully planned. The episodes should be read from the lowest range upwards, starting with the Tree of Jesse at the west end of the north wall. The story of the Virgin starts at the west end of the south wall, and chronologically they converge at the east, with the Resurrection and Ascension of Christ left of the window, mirrored by the Assumption and Coronation of the Virgin to the right. Note, in the north-west window, the Annunciation, with Gabriel in the left-hand embrasure and Mary opposite, a typical arrangement found in many sculptured doorways and painted schemes often across chancel arches. The other window embrasures are painted with standing figures of saints Peter and Paul flanking the east window. All the stained glass has been destroyed, but it is a reasonable conjecture that the subject matter would have complemented the paintings. Since the Virgin is mentioned rarely, though significantly, in the Gospel narrative, her story was developed from early Christian times in response to popular demand. The version here is based on *The Golden Legend*, a compilation of saints' lives produced *c*. 1280. The paintings with their red and ochre colour range and tall, swaying figures with elegant draperies are very similar to contemporary English and French illuminated manuscripts.

The nave of the church, wide and light, dates from the late twelfth century and the thirteenth century – differences in the arches and capitals of the arcade suggest that the aisles are not exactly contemporary. A recent conservation programme included a new glazed entrance door in the south porch, with ironwork representing the Tree of Life by Michael Jacques and new choir stalls and organ case designed by the church architects, Caroe and Partners.

## 8. St Mary's Church, Charlton-on-Otmoor

This charming church stands in the middle of the village, the churchyard raised above the street and the porch at the top of the steps. The interior, although aisled and spacious for its size, feels intimate and welcoming. Before going in, though, walk around the outside to look at the beautiful flowing tracery in the chancel windows, which are better appreciated from the exterior. The chancel was built in the fourteenth century when the ogee arch – a sinuous reversed curve – was fashionable for window tracery and decorative details, and very occasionally used on a large scale for structural arches. The chancel is plain inside, but ogees appear on the sedilia and piscina next to the altar.

The nave columns are octagonal with plain round capitals above and equally plain arches, but any suggestion of solidity is obviated by the width of the arches and the main vessel of the nave. Traces of red paint, particularly at the west end, may reflect the original scheme. But look up at the timber-framed roof. This is original fourteenth-century work, a pitched rafter roof with three longitudinal purlins. Braced tie beams separate it into bays, and in the gap between the tie beams and the topmost purlin are inserted wooden arches with gently cusped decoration.

Yet the object that you will see as soon as you enter the church is the wooden rood screen. This dates from the early sixteenth century and is probably the

finest screen in Oxfordshire. Linenfold panelling supports the upper openwork 'windows', with their rudimentary Gothic tracery, leading to the coving. Here is a rich pattern of decorative vaulting ribs, leading to the bressumer or beam with a delicately carved vine trail, a common motif for screens. The paint, which was put on in the nineteenth century, is said to reflect the original colour scheme. This rood screen, which would have supported a carved group of the crucified Christ

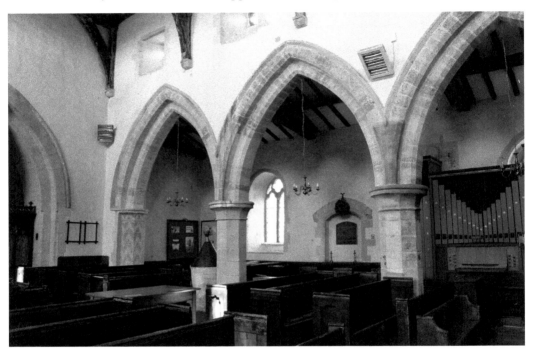

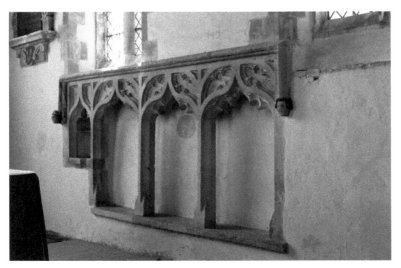

*Above*: Interior of St Mary's Church, Charlton-on-Otmoor, looking north-west.

*Left*: Sedilia.

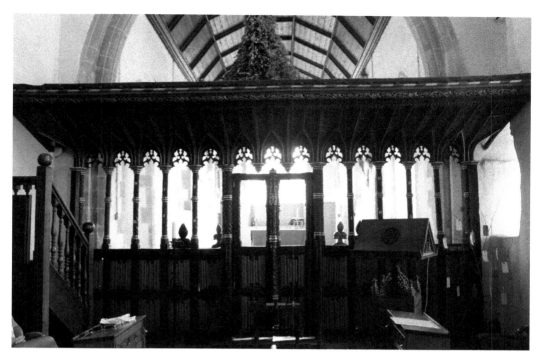

Rood screen.

between St Mary and St John, must have replaced an earlier one since it bears no relation to the openings in the south wall next to it, which would have allowed access to the upper part.

Above the screen on the south side there is a fragment of a fourteenth-century wall painting, and in front of the screen at its north end is the beautiful pulpit, dated 1616, and shaped rather like a tulip.

## 9. ST MARY'S CHURCH, CHIPPING NORTON

St Mary's, tucked down in a dell between the marketplace and the remains of the twelfth-century castle site, is barely visible from the town centre, which was moved up the hill in the later Middle Ages. Nevertheless, it has a number of unusual and intriguing characteristics and is well worth seeking out.

In the fourteenth and the fifteenth centuries Chipping Norton became one of the main Cotswold wool towns. Although the building of St Mary's is not documented, it is included in the group of famous wool churches of Oxfordshire and Gloucestershire that were built by wealthy local merchants, since it has characteristics in common with the equally splendid wool churches of Northleach and Chipping Campden. Once you come out in the churchyard, more or less at the level of the church itself, you see how imposing it is, with its huge, continuous nave clerestory; and the interior, although much restored and plain, is high, well lit and adorned with delicate mouldings and surface decoration.

The fourteenth-century entrance porch is unusual in itself, being hexagonal in shape. Hexagonal porches are extremely rare – a possibly contemporary, though on a grander scale, is the north porch of St Mary Redcliffe in Bristol. Given that Cotswold merchants exported wool through Bristol, there could be a connection, though none is proven. Here the vault bosses are carved with a variety of grotesque faces, perhaps apotropaic, to ward off evil at the church threshold.

There are two aisles on the north side and one on the south. Their arch mouldings and some of the windows suggest dates in the thirteenth and fourteenth centuries, but the main vessel of the nave was apparently rebuilt in the fifteenth century, possibly in association with the foundation of the Trinity Guild in 1450. This does raise questions about how it was done, and whether the cores of the nave piers, which are cylindrical, their surfaces concealed by slim colonnettes, were actually reused from the former building. In their present form the piers ascend without interruption halfway up the clerestory, which fills each bay between the piers. Panels of blind tracery below the windows suggest an intermediate storey, and the spandrels of the arcades are filled with more blind tracery motifs. Above the chancel arch is the eastern clerestory associated with other Cotswold wool

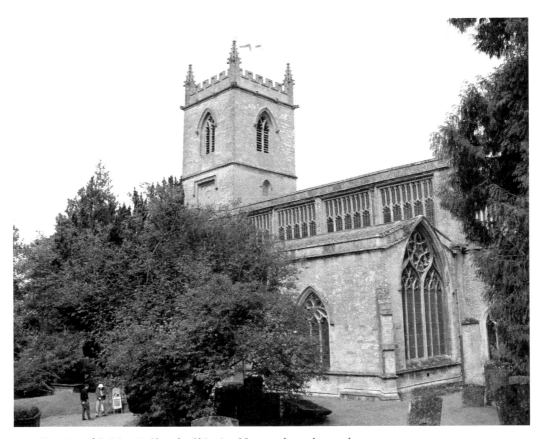

Exterior of St Mary's Church, Chipping Norton, from the south-east.

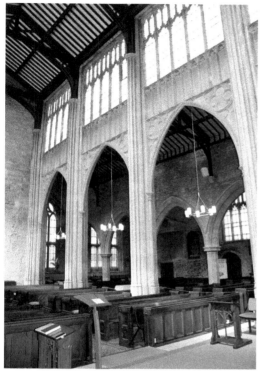
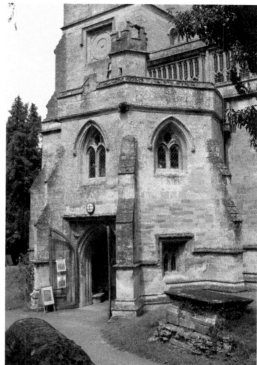

*Above left*: Nave elevation.

*Above right*: Hexagonal porch.

churches. The one here has an inner layer of purely decorative tracery round the top of the window. This must be one of the grandest late medieval church interiors in the area, and although comparisons have been drawn between Chipping Norton and the nave of Canterbury Cathedral, a closer but not exact parallel can be seen in **St Mary's Church, Oxford**, the university church, which also has similar capitals.

The chancel is dull and dark by comparison with the nave, but the window tracery throughout rewards study, from the flowing tracery of the east window of the south aisle to the austere Perpendicular panels of the north aisle – plain without cusping.

## 10. ST KATHERINE'S CHURCH, CHISLEHAMPTON

St Katherine's is a beguiling eighteenth-century preaching box, small, intact and built in 1762 by Charles Peers who, four years later, built Chislehampton House immediately to the south.

Between the Reformation of the sixteenth century and Gothic Revival of the nineteenth, churches, if they were built at all, had no projecting chancel.

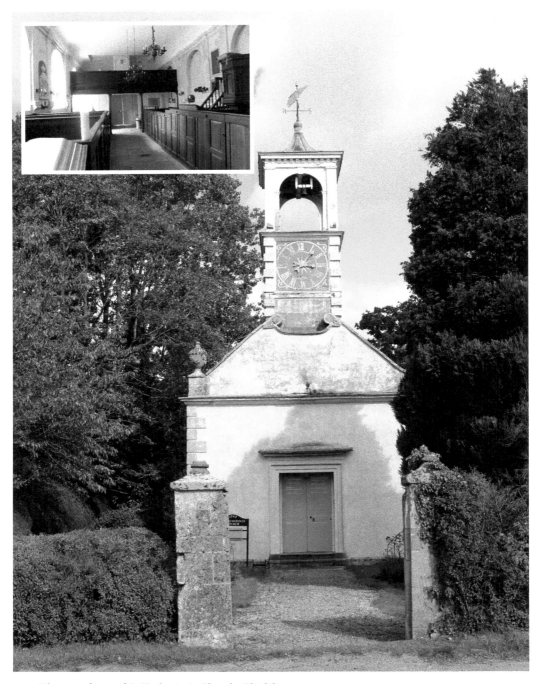

The west front of St Katherine's Church, Chislehampton.

*Inset*: Interior, looking west.

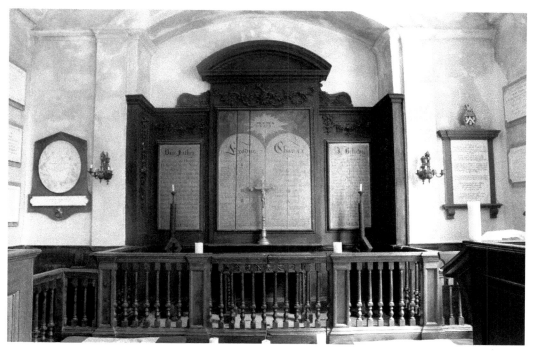

The Sanctuary.

As such, St Katherine's is a rectangle, the sanctuary marked on the inside by altar rails. Its west front, with a simply framed door, has a cornice and gable, weighed at the base by two cheerful stone urns. The top of the gable is scooped out and finished by scrolls, and from this rises a little wooden clock tower with white-painted, rusticated corners that contrast strangely with the creamy stucco beneath.

Inside is a complete Georgian interior with a west gallery, box pews and a pulpit of Jacobean style on the north wall – set high above the pews so the preacher could keep an eye on the entire congregation. The walls are articulated by arches, blind on the north and east walls, cut through with windows on the south, and flanked by pilasters that rise from above the level of the pews to a heavy cornice below the shallow barrel vault of the roof. The north wall is taken up with memorials to the Peers family, including Charles himself. The east wall is dominated by the sanctuary rails, the altar table and the altar screen, which displays the Lord's Prayer, the Ten Commandments and the Creed, for in this era of strict Protestantism the Word was all and should be available to all the faithful.

Chislehampton House was designed by a London builder, Samuel Dowbiggin, and the church has also been attributed to him, but this cannot be proven.

## 11. St Swithun's Church, Compton Beauchamp

Unlike most churches in Oxfordshire, which are built of limestone, Compton Beauchamp's is chalk with some sarsens (the stone forming the outer circle at Stonehenge). This reflects the position of the tiny village, in the Vale of the White Horse, below the chalk downs and close to the county boundary with Wiltshire.

St Swithun is tucked into a sloping graveyard next to the big house with which it shares a drive. Lacking the usual late medieval parapet concealing a flattish roof, the church looks small and homely. Its exterior recalls old-fashioned toy bricks, seemingly composed of rectangular blocks, upright for the tower with its pyramidal roof, horizontal for the nave and chancel. The porch and transept-like chapels project north and south, but there is no true crossing within. From the windows it seems that the building dates from the thirteenth to fifteenth centuries, with a fine north window from around 1300, and smaller Perpendicular openings in the side walls and tower. There is no clerestory, and the steeply pitched roof of the tall, narrow nave rather engulfs the tower.

Charming though the church looks from the outside, its interior is the more arresting. Around 1900 Lydia Lawrence decorated the plain little chancel with stencils of foliage, flowers and vine scrolls in reds, blues and greens on the whitewashed ground. She was a member of the Kyrle Society, which had been founded in 1876 by Miranda, sister of Octavia Hill, to bring the arts and green

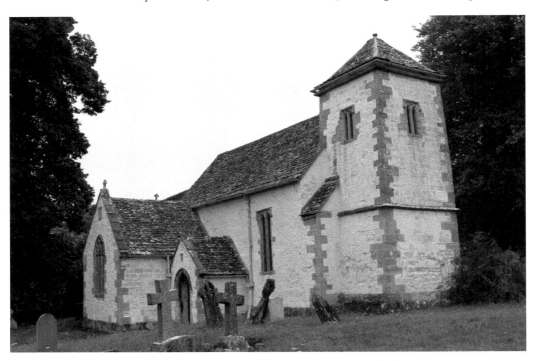

Exterior of St Swithun's Church, Compton Beauchamp, with the north chapel.

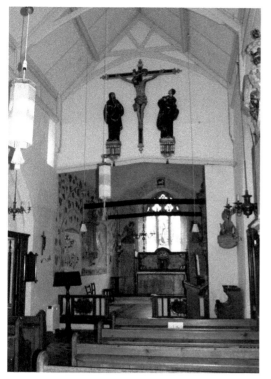 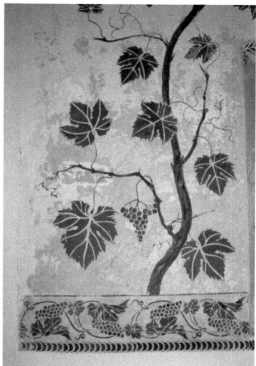

*Above left*: Interior, looking east.

*Above right*: Paintings in the chancel.

spaces to the poor. William Morris was a supporter and a possible influence on Lawrence's style. It seems also to anticipate some textile work by the Omega Workshops. Birds and other creatures were added *c.* 1967 by Anthony Baynes and T. L. B. Huskinson.

After Lawrence, the church fittings were transformed in the 1920s and 1930s at the expense of a local Anglo-Catholic, Samuel Gurney. He employed the stained-glass artist and decorator Martin Travers (d. 1948) to make a font cover, the rood over the chancel arch, a new altar, altar rail and screens, and install a tiny Lady chapel under the tower. The wooden font cover, with its onion dome over rounded arcades, hints at eighteenth-century Gothic. Travers specialised in mixed materials; the rood cross is of wood, but the figures of St Mary and St John are of papier-mâché. The dark, flat relief of the Virgin and Child in the Lady chapel is touched with gilding. There are relics in the altar here and in the north chapel, as this church community continues the Anglo-Catholic tradition and is along a pilgrimage route.

Do not miss the memorials to the eighteenth-century mother and daughter Rachel and Anne Richards, still vivid from their epitaphs.

## 12. BAPTIST CHAPEL, COTE

Nonconformists were active and successful in Oxfordshire, especially during the eighteenth century when the Anglican Church was drifting; it was only the revivalist movements of the nineteenth century that precipitated their decline. Many Baptist chapels, small and plain, are now dwellings. The Historic Chapels Trust took over Cote's chapel in 1994. The building is a gem.

Set deep within its burial ground, the chapel was first built in 1703, but was effectively reconstructed in 1756 and further alterations were made in 1859. Constructed of pale, slightly gleaming limestone rubble, it is square in plan with a gabled east front, topped by a small rectangular plaque with flanking scrolls. This conceals the original arrangement, best seen from the back of the chapel, of a roof with twin gables. The east front has two entrance doors with a round-headed window between them and three similar windows above. All is plain, beautifully proportioned and calm.

The interior, which dates from the 1859 refurbishment, is almost all wood: full of pews, with galleries on three sides supported on thin iron columns. The imposing pulpit was moved to the west wall from the south, and in front of it, set into the floor among the pews, is the deep baptismal tank. This has no drainage or tap, and the water source, how the tank was filled and how it was emptied are much debated.

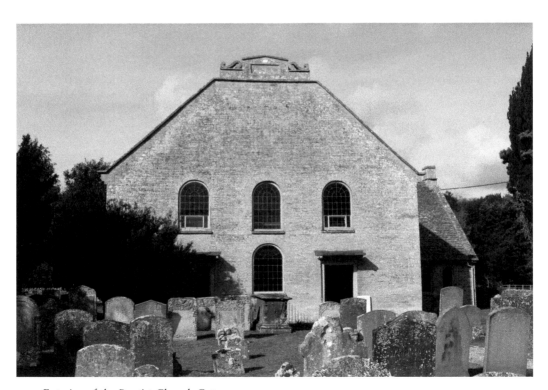

Exterior of the Baptist Chapel, Cote.

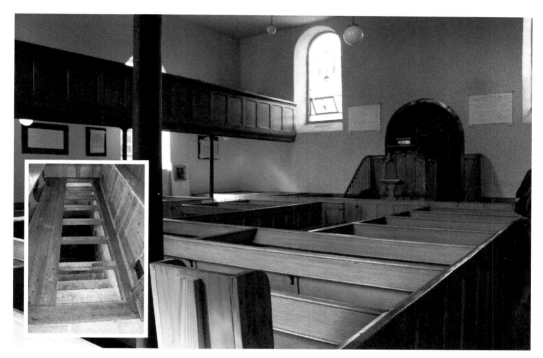

Interior.

*Inset*: Baptismal tank.

## 13. St Mary's Church, Cropredy

This church hugs an elevated position above the Oxford Canal, which runs from Warwickshire to Oxford and was completed in 1790. The village, around 3 miles from **Banbury**, is much older, being an Anglo-Saxon minster site. St Frimond, a miracle-working saint associated with Cropredy church, was allegedly the son of Offa, the eighth-century king of Mercia.

What we see now dates mostly from the fourteenth and fifteenth centuries. The church is built of ironstone, and it is worth taking time to look at the fine display of window traceries outside before going in – from Geometric, through Flowing to the calm rigidity of Perpendicular. In the east wall you can see that the vestry, built north of the chancel, has an upper storey with a little window. This was a room for the priest.

The interior is unplastered, big and high, with wide aisles. In the nave the fourteenth-century arcades have no capitals. The piers and arches have continuous mouldings, the same all through, that are uninterrupted by capitals. This form does occur elsewhere but it is unusual. Notice in the north aisle the plain, polygonal twelfth-century font, which was superseded by the dull Victorian one next to the entrance but has now been reinstated for baptisms and the later one made redundant. The north aisle also has a fine set of Perpendicular windows

and a surviving piece of medieval stained glass – a head of the Virgin Mary dating from the fifteenth century.

The brass lectern, an eagle standing on a globe, is also fifteenth century, probably from the south Netherlands. These pre-Reformation lecterns are now very rare; this one is the only example in Oxfordshire outside Oxford itself. The pulpit, apparently of local workmanship with Gothic panelling, was once dated 1619. Both these pieces survived the restoration of the church by Ewan Christian in 1876.

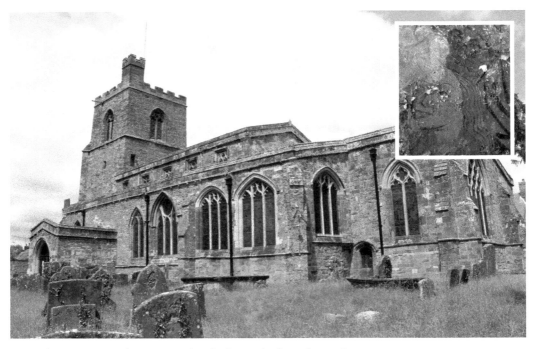

*Above*: Exterior of St Mary's Church, Cropredy, from the south-east.

*Inset*: Last Judgement painting, the Virgin with a gilt crown. (© Chris Mitchell)

*Below*: The dragon beam. (© Verna Wass)

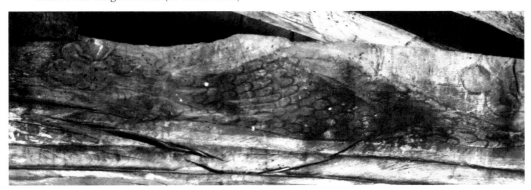

The present clerestory also dates from the fifteenth century or perhaps the late fourteenth, since it seems to go with the wooden roof. Above the chancel arch are the remains of a wall painting of the Last Judgement. The details are barely visible, but it is thought to be the third such painting in this position. While some years ago the painting was being recorded in detail, conservators noticed that the roof beams were part of the same scheme. In the centre are carved heads, including a bishop and a lady, confronted from either side by long, sinuous dragons with extended foliate tails. To see these details you need time, a good torch and a pair of binoculars, but your patience will be rewarded.

## 14. ST JOHN THE BAPTIST CHURCH, CURBRIDGE
Curbridge, just outside Witney, was raised to parish status in 1905, and the distinguished ecclesiastical architects Nicholson and Corlette were commissioned to replace the wooden former chapel with a new stone church. Although Nicholson was trained by the Gothic Revival architect J. D. Sedding and normally worked in that idiom, St John the Baptist Church, Curbridge, which he built 1905–06, is a delightful small and complete Arts and Crafts church.

A single-storey, single-cell church, it sits right at the back of the churchyard and is easily missed. It is built of coursed rubble and the tiled roof comes low over the south side, under which are tucked a vestry and organ chamber fronted by a row of quatrefoil windows. Two turrets interrupt the horizontals – one a chimney, the other the belfry.

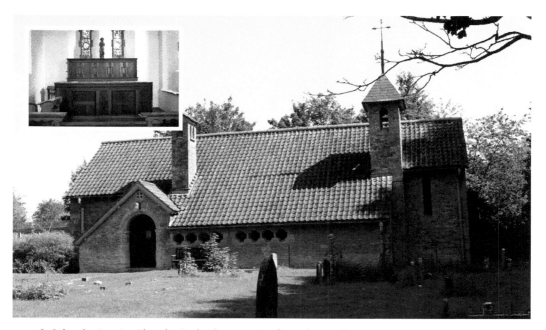

St John the Baptist Church, Curbridge, exterior from the south.

*Inset*: Curbridge altar.

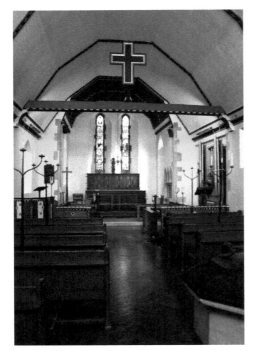

Interior to the east.

    The interior, which is beautifully maintained, has all its original furnishings and colour. Nicholson designed the fittings and, except for the altar and font, had them painted in green, red and white, including the crossbeams under the roof. The only Gothic elements can be seen in the piscina, a piece of thirteenth-century revival, and on the altar and its screen, which have motifs in relief that are partly Perpendicular and partly hint at art nouveau.

    The two lancet windows in the east wall above the altar have their original stained glass, designed by Charles Nicholson's brother, the artist Archibald Keightley Nicholson.

## 15. ST PETER AND ST PAUL'S CHURCH, DORCHESTER

Dorchester is a former Augustinian abbey (that is, a college of priests rather than cloistered monks), of which only the church survives. Huge and impressive, it is also architecturally extremely puzzling. The apparently early details in the fine west tower, for example, are deceptive, for the tower was rebuilt in 1602 in an antiquarian manner. The original cruciform, un-aisled twelfth-century church was embellished with extra chapels from the late thirteenth century, until the narrow nave led to a vastly expanded east end into which the transepts were incorporated. This was all done probably in honour of St Birinus, missionary to Wessex in the seventh century, whose shrine was established here. The wide aisle flanking the nave to the south was added in the late fourteenth century and evened out the building's appearance.

    All these changes are very enjoyable for those who like to puzzle out building phases, but those who do not can spend time with the contents of the church,

which are worth a journey in themselves. Before going to the chancel note in the south aisle the magnificent lead font, dating from around 1170 and decorated with figures of the Apostles, seated under arcades. Nearby is a pier with a curious kind of misplaced capital, carved in the fourteenth century with monks and foliage, sculpture of the highest quality.

The nave walls are the only part of the church that show features from the twelfth century. Beyond the former transept crossing everything is later. Go to the easternmost bay, which projects beyond the aisles and has three astonishing windows, made around 1340. The east window, bizarrely divided by a buttress, boasts a wheel design inserted by William Butterfield, the building's chief restorer in the mid-nineteenth century. All the windows are decorated with ballflower ornament and filled with tracery that incorporates sculptured figures. In the east window they enact scenes from the Passion and Resurrection of Christ. The north window is devoted to the Tree of Jesse: the tracery has become the tree, rising from the figure of Jesse, reposing on the windowsill. In the south window are figures of saints and monks carrying the bier of St Birinus. Much of the stained glass remains, and when it was complete the glazing and sculptural programmes complemented each other in a manner that epitomises the aims of the Decorated style.

The south choir aisle was the site of St Birinus's shrine, of which fragments have been incorporated into an unfortunate modern reconstruction. Several tombs are also collected in this area, including an effigy of a knight, dating from the late thirteenth century and one of the finest of its type. It may represent William de Valence, a half-brother to Henry III. He lies cross-legged, his hand on the hilt

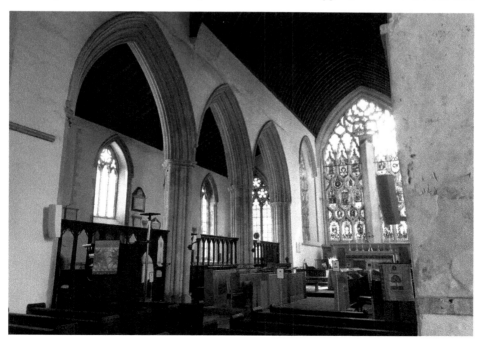

Choir and north aisle interior of St Peter and St Paul's Church, Dorchester.

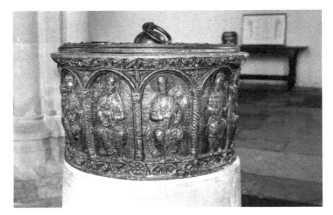

The font.

*Left*: Detail of Jesse window.

*Below*: Effigy of a knight.

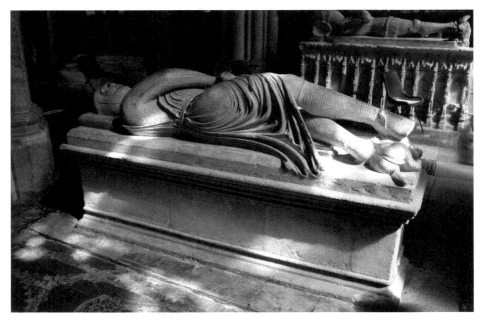

of his sword. Although a belief still persists that cross-legged effigies represent crusaders, this is not so. A more plausible explanation is that they are knights for Christ, rising from their tombs to combat sin. This figure combines naturalism with formality, the folds of his tunic falling in graceful stylisation across his body.

## 16. ST MARY'S CHURCH, EWELME

'God's House at Ewelme' is more than a simple church. It is a group of buildings that takes us back into the world of late medieval piety, in which people provided for their souls after death by founding a chantry, often a chapel, where priests prayed daily on their behalf. Ewelme is a very grand chantry. William and Alice de la Pole, the future Duke and Duchess of Suffolk, were given royal permission to found an almshouse at Ewelme in 1437. The statutes drawn up *c.* 1448–50 stipulate that thirteen poor men and two priests were to be housed there with their duty of prayer in the church to which the almshouse was attached. What is so special about Ewelme is that the church and almshouse survive together with the school, which was an afterthought. The church is built of stone and flint, the almshouse and school of mellow brick. Seen from the north side, the line of buildings seems almost to cascade down the steep slope from the churchyard, the almshouse below the church and the school at the bottom of the hill. The flower-filled graveyard, courtyards and gardens add to the tranquillity.

The church was begun by Alice's father, Thomas Chaucer, the son of Geoffrey Chaucer, the poet. The lower part of the tower and the south wall of the nave are attributed to his patronage, but the rest was mainly the work of the formidable and capable Alice after William was murdered in 1450. From the exterior the building seems wide and squat, with a heavy parapet and a pattern of chequered flint on the east wall. This is one of several apparently conscious references to the base of the de la Poles at Wingfield, Suffolk, where Alice was involved in another chantry foundation.

Inside, the architecture is much lighter, in both senses, the large Perpendicular windows in the aisles and clerestory illuminating the thin walls and slim quatrefoil piers. The arcade runs straight through to the east without a chancel arch – the chancel and nave are differentiated only by screens. This also recalls Suffolk churches, as does the tall font cover given by John, Duke of Suffolk, in 1474.

There is much figurative sculpture between the nave arches, but the greatest sculpture of all is on the alabaster tomb of Alice herself. This is in the chapel of St John the Baptist opening eastwards from the south aisle, and the tomb occupies an arcade bay on the north side, visible from both the chapel and the chancel. The sarcophagus is placed under a stone tester with massive cornices adorned with angels. More angels stand under canopies on the sides of the tomb, acting as weepers and holding shields of arms that represent the connections of the Chaucer family. Alice's effigy lies in an attitude of prayer, dressed in robes appropriate to a widow, but with a ducal coronet and the Order of the Garter on her arm. The figure looks both opulent and pious. Yet deep under the base of the sarcophagus a very different figure is visible. For this is a cadaver tomb, in which a decaying skeleton lies beneath the effigy as a reminder of what will happen to the body after death. This one, however, is different in that it is the only surviving cadaver of a woman,

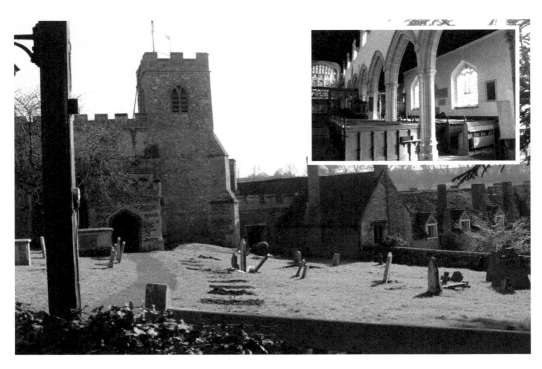

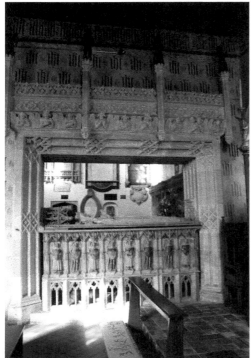

*Above*: St Mary's Church, Ewelme, and almshouse from the north-east.

*Inset*: Interior, south arcade.

*Left*: Tomb of Alice, Duchess of Suffolk, south side.

and rather than acting as a reminder to the living it seems to focus on images of saints painted on the roof above. Traces of colour on the tomb add to its interest.

At the west end of the church are the steps leading down to the cloister of the almshouse, steps trodden by the feet of the thirteen poor men. The cloister is open to the public and should not be missed.

## 17. ST MARY'S CHURCH, FREELAND

Oxfordshire boasts work by the finest High Victorian architects of the Gothic Revival. The architect of this church was John Loughborough Pearson (d. 1897), who at this time (1866–71) was a keen follower of the High Anglican Oxford Movement. Freeland church is, therefore, all about the 'beauty of holiness' towards which such churches aspired.

An aisleless church, its smooth exterior with an apse and a tower tucked against the north side has minimal decoration and smallish windows. Its apparent simplicity is no preparation for the glories within. Though the nave is dark, the chancel is bursting with colour and ornament. The two-bay chancel is raised and approached through a low stone screen with a wrought-iron superstructure supporting the cross. The chancel and the apse are rib vaulted; the apse vaulting in particular gives a French Gothic feel to it. The decoration survives complete with Minton floor tiles, stained glass and wall paintings by the famous firm of Clayton and Bell, who worked in the church mainly from 1868 to 1883, though the wall paintings were not finished until 1890.

The wall paintings are in the style of the thirteenth century as mediated through the nineteenth, flattish and with much emphasis on graceful drapery rendered in graphic lines. The story, in fact, begins with the font at the entrance

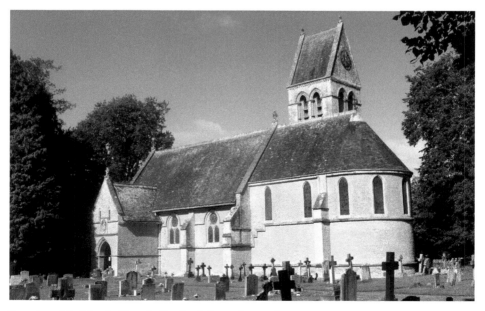

Exterior of St Mary's Church, Freeland, from the south-east.

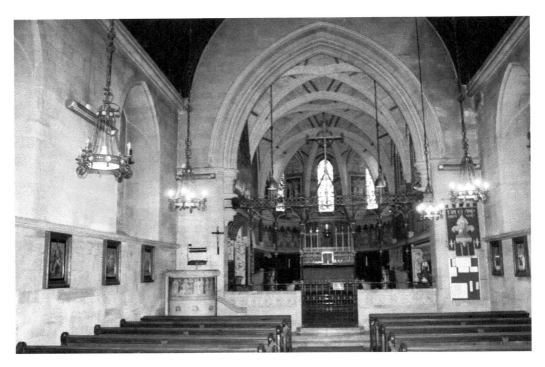

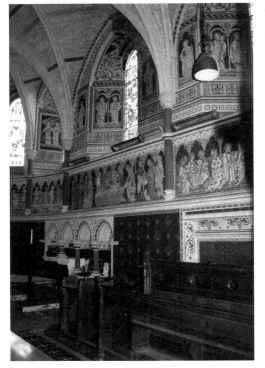

*Above*: Interior, looking east.

*Left*: Paintings in the chancel.

and proceeds via the stained glass and the pulpit into the chancel, telling the story of the Incarnation, Baptism and Christ's journey to his Passion and Pentecost, a journey undertaken metaphorically by every Christian. The font and the pulpit are painted with white figures on a dark red ground. In the chancel the colour palette is consistent with this, but adds greys, greens, blues and pinks. However, there is an overall dominance of dark red, which also features on the stonework. The scenes of the Passion of Christ and the Pentecost are clearly readable, unfolding around the walls and windows like a tapestry: the figures, in predominantly white draperies, are set under a continuous arcade, white against the coloured ground. The sequence is interrupted only at highly significant moments in the story, such as the Pentecost on the south wall, which interrupts the arcading to set Mary and St Peter against a blue starry background with the Holy Spirit, represented by a dove, descending from a fiery halo. Any surface not taken up with the narrative scenes is filled with foliate trails and other ornament, which add to the impression of richness.

The stained glass, with a broader palette of colours, complements the narrative of the paintings – again, in a style that reflects medieval glass while remaining resolutely of its time. The whole scheme is of the highest quality, scarcely matched anywhere in the county.

## 18. ST PETER'S CHURCH, GREAT HASELEY

St Peter's is a large, spacious church, which preserves its two main building periods remarkably well: the aisled nave of *c.* 1200 leading to the chancel built around 1290. Thus, we move from very late Romanesque, verging on early Gothic, to one of the best examples of Decorated in Oxfordshire. Entry is through the west tower, which is Perpendicular with a reset thirteenth-century entrance door.

In the nave, cylindrical piers are topped by capitals with stylised foliage under heavy, square abaci that support the arcade and thick upper wall. The foliage is typical of late twelfth-century work in Oxfordshire, influenced by the capitals in St Frideswide's, Oxford (now the cathedral). The arches are pointed, surmounted by hood moulds that are linked at the base in a continuous line, not unlike the design at **Chalgrove**, though the arches here are not chamfered, but broad and plain. The chancel arch is surprisingly low, giving you very little idea of what lies beyond. To see the building in its full majesty it is best to stand under the chancel arch and look westwards, then eastwards into the chancel.

The chancel opens up into a single space, much higher than the nave, lit by two-light windows at the sides and a huge five-light window at the east. The tracery motifs, of pointed trilobes, turned quadrilobes, and spherical triangles within a circle at the head of the east window, reflect up-to-date London work, possibly mediated through the recently built Merton College chapel in Oxford. On the south wall are a piscina, sedilia under tall arch-and-gable motifs, and a tomb recess decorated with openwork cusping along the arch. The patron is unknown, but this area, including Chalgrove and **Rycote**, attracted merchant-gentry with connections to London who held their land for several generations, among them the Barentin family, some of whom were buried in the chancel at Chalgrove and also held property here.

The east bays of the nave, which are fourteenth-century work, perhaps replaced a former chancel, from which the present one was built eastwards. The east end of

the south aisle, a chantry chapel, was given a Decorated piscina and has a double squint through to the high altar. A row of tomb recesses line the south wall, and here is also a battered effigy of a knight in a cross-legged pose, tantalisingly contemporary with the Decorated work.

There is fine nineteenth- and twentieth-century stained glass throughout the church. The chancel was glazed by Hardman & Co., the great firm of church decorators, between 1855 and 1865. The high altar was reordered in the 1930s by the architect Geoffrey Webb with a pink damask embroidered hanging.

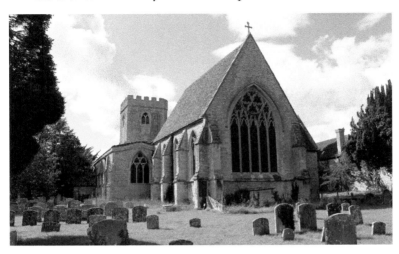

*Left*: Exterior of St Peter's Church, Great Haseley, from the east.

*Below*: The piscina and sedilia.

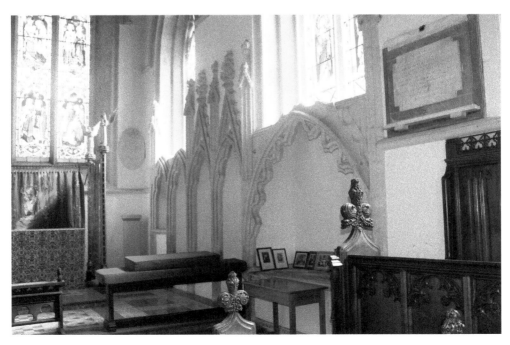

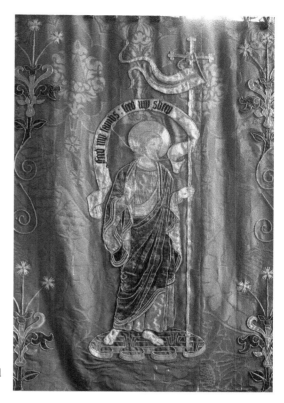

Detail of the altar dossal with the resurrected Christ.

## 19. ST MICHAEL'S CHURCH, GREAT TEW

The church stands low down in its sloping churchyard at the edge of Tew Park. You approach through a seventeenth-century gateway and along a path that was formerly the carriageway to Great Tew House; you might wonder if the many fine trees planted in the nineteenth century were placed deliberately to enhance the setting of the church. From above, the church, with its fifteenth-century clerestory and battlemented tower, looks late medieval, but down on the main level you see a much earlier building – some traces of the pre-Conquest church that was the centre of a large group of parishes.

The south entrance door is late Norman, like many in the area, with a fine display of billet and chevron ornament, but an inner order with openwork tracery was evidently inserted a century later when the door was moved to accommodate the new south aisle. The comparatively simple chancel once had much larger windows, which were reduced in size by Thomas Rickman, an early proponent of the Gothic Revival and the man who defined the periods of English medieval architecture as Norman, Early English, Decorated and Perpendicular. Rickman restored the church in 1826, an event recorded on a painted board in the nave. The chancel and aisles have fine, sophisticated window tracery and wall paintings of the Passion of Christ, hinting that the patrons of the church, who are entirely unknown to us, were well aware of the smart trends of their day. The memorial

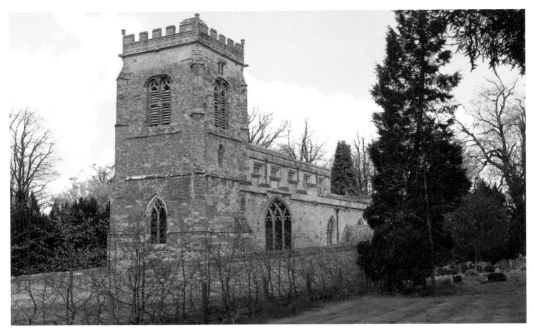

*Above*: Exterior of St Michael's Church, Great Tew, from the west.

*Below*: Nave south arcade looking south.

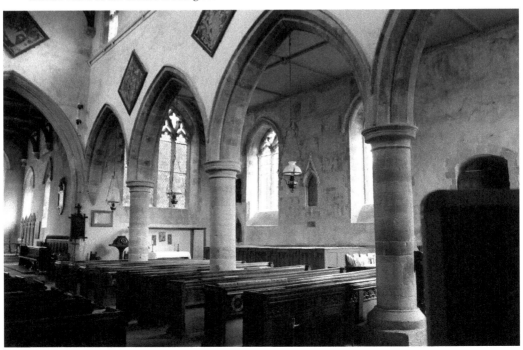

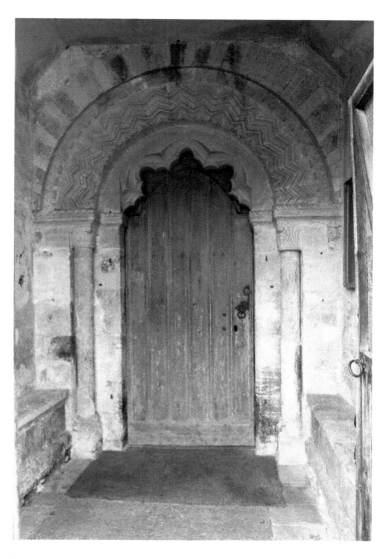

The south doorway.

brasses of Sir John and Alice Wylcotes, which are later in date, suggest links to the Wilcotes of **North Leigh**, but nothing is certain.

Rickman provided chancel sedilia in a Gothic Revival style, but he modified the north wall of the chancel to contain the tomb of Anne Boulton (d. 1829), carved in white marble by the sculptor Francis Chantrey, in delightful neoclassical contrast to this Gothicism. Her full-length figure in contemporary dress reclines against a fat cushion on what is effectively a daybed. She holds an open book in her lap. The tomb-chest, however, is decorated with blind panelling in Perpendicular style and an edging of Gothic foliate motifs. Chantrey had made a similar effigy for the tomb of Charlotte Digby in Worcester Cathedral, but while Charlotte looks ecstatic but uncomfortable, Anne seems content with her final resting place.

## 20. St Peter's Church, Hanwell

Hanwell is conspicuous for the abundance and quality of its sculptured ornament. It is one of the Ironstone Churches of north Oxfordshire, so-called owing to the iron content of the local limestone, which is rich enough to produce iron ore. The stone is brownish, almost golden in sunshine, and it was used extensively for houses as well as churches.

St Peter's stands at the end of a narrow lane above a deep dip containing what is left of Hanwell Castle, once a huge brick house built around 1500 by a prominent royal servant. The church, which dates from the fourteenth century, was built and the decoration designed by the same master mason who worked at **Adderbury**, Bloxham and Alkerton – similar distinctive capitals and cornice friezes are prominent here. The sculptors themselves may have been a different group. The square tower dominates the west end, making the wide aisles seem rather squat, but this is because the tower seems to be partly buried by the nave clerestory, which was a later addition. The window tracery of the aisles is unadventurously early Decorated – adventurousness was reserved for the interior and the chancel.

The nave has three bays with aisles. In the south-west corner is a small fireplace, its chimney rising above the aisle roof. The arcades have chamfered arches resting on quatrefoil piers with large octagonal capitals. These display carved male and female busts, the men with linked arms, as at Adderbury. Their aggressive,

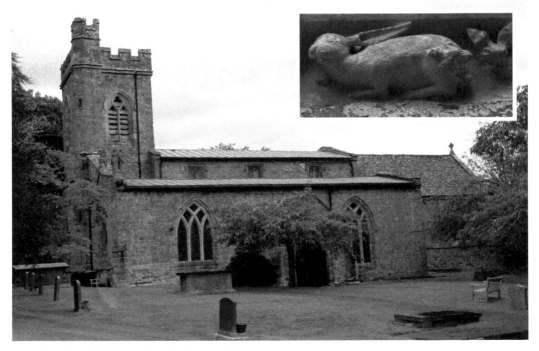

Exterior of St Peter's Church, Hanwell, from the south-west.

*Inset*: South frieze, showing detail of a hare.

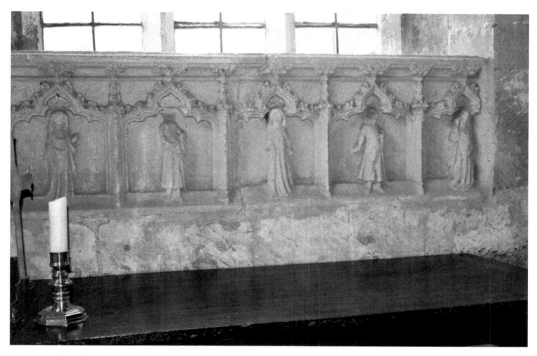

North aisle with the fourteenth-century reredos.

crouching pose challenges the visitor rather in the manner of the direct gaze of a painted portrait. In the south aisle above the capitals are figures of musicians playing pipe and rebek, a form of early violin.

The chancel has what was once a good set of sedilia with moulded arches, now reduced by the raising of the chancel floor. Before inspecting the exterior frieze of the chancel, look at the relief sculpture on the east wall of the north aisle. This is now in the position of a reredos, but the panel depicts a row of weepers and it probably comes from a tomb-chest. Judging by the graceful sweep of the draperies, this is roughly the same date as the church.

The exuberant frieze on the north and south cornices of the chancel displays various monsters of the half-human/half-beast kind, along with huntsman and hounds, individual creatures such as a dragon and a hare, and figures that may represent the Virtues and Vices. The stone is a contrasting white limestone, probably from the Taynton area near Burford. This is a less-friable stone of enduring quality and easy to carve when freshly quarried. The friezes here and at Adderbury have had to be conserved only recently, having survived more than 600 years.

## 21. ST MARY'S CHURCH, HENLEY-ON-THAMES

St Mary's stands prominently in the town centre, at the west end of the bridge over the Thames; its exterior flaunts a chequerboard pattern in squares of stone and flint. The tower stands proud at the west front, facing Hart Street and the

marketplace. The tower is sited over the end of the north aisle rather than the nave, for the church has a complicated building history, made more confusing by successive restorations. Typical of many urban churches built at the height of the town's medieval prosperity, the interior is broad, spacious and welcoming.

The main body of the church was built in the later thirteenth century, with chapels added over the following centuries, and the tower attributed to the patronage of John Longland, Bishop of Lincoln 1521–47, so built just as the Reformation was getting under way. The existing nave piers are tall, slender cylinders with rather vaguely moulded capitals and bases. They do not feel right for the thirteenth century and, while they may have been remodelled in the fifteenth when the clerestory was added, a recorded rebuilding of the south aisle in 1789 gives another possible date – the piers would sit more happily in an early and unscholarly Gothic Revival of the eighteenth century than in the Middle Ages. Certainly, the Perpendicular work at the east end of the nave has all the assurance and expert handling that are lacking in those further west.

There is good Perpendicular work in St Leonard's chapel, north of the chancel, which was built by John Elmer (d. 1460), complete with a battlemented parapet and gargoyles. Its west window now opens on to the northernmost aisle of the

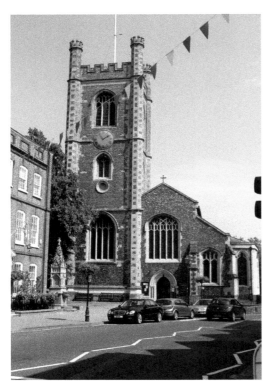 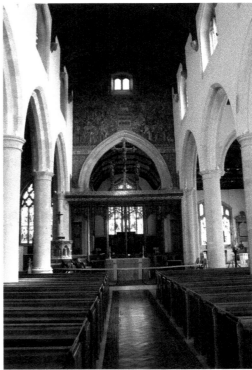

*Above left*: The west front of St Mary's Church, Henley-on-Thames.

*Above right*: Interior, looking east.

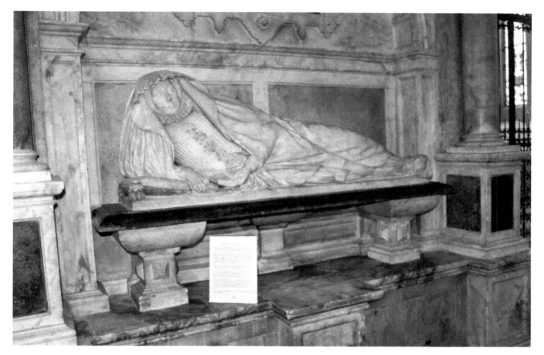

Effigy of Dame Elizabeth Periam.

nave, which was added by Benjamin Ferrey (d. 1880), who restored the whole building in 1853–54. He had a fine time here with Decorated tracery and put in new liturgical fittings in the chancel.

The splendid tomb beside the entrance to St Leonard's chapel is of Dame Elizabeth Periam, who died in 1621. Its alabaster and black marble, with simple Tuscan Doric columns, frames the effigy of Dame Elizabeth, still propped energetically on one elbow and expressing in sculpture the restrained wealth we find in contemporary painted portraits. At the entrance to the chancel is a rood screen with the figures of the crucified Christ between St Mary and St John, an impressive piece dating from 1920, but designed in medieval style by George Fellowes Prynne (d. 1927) to replace the former rood, destroyed at the Reformation, the traces of which can be seen in the side walls of the chancel arch.

All this is surrounded by a magnificent sequence of Victorian stained glass, the best at the east end designed in 1868 by Hardman & Co. It is rare to see such a complete and consistent programme, and the wide arcades with good natural lighting in the church show up the rest to the best possible effect.

## 22. St Peter's Church, Hook Norton

Hook Norton is a large, hilly village with a famous brewery. The church, opposite the conveniently placed Sun Inn, is raised above the level of the High Street and built of the ironstone characteristic of Oxfordshire north of Chipping Norton. Its tall Perpendicular tower is visible from some approaches.

Hook Norton was a centre of Christian mission in Saxon times, and the church may be built on the site of an early predecessor. It is large, with a plain, lofty interior. It seems to date mostly from the thirteenth and fourteenth centuries, with octagonal piers in the nave and an instructive series of windows displaying tracery types popular either side of 1300, with intersecting lines, pointed trefoils and one with the net pattern known as reticulated. Above the chancel arch at clerestory level is a Perpendicular window lighting the nave from the east, a distinctive feature that you can see also in **Chipping Norton** church and in some of the greater wool churches of the Gloucestershire Cotswolds.

This late medieval work is, as so often, no guide to the church's long history. The plain-looking side windows of the chancel show its twelfth-century origins, and if you look more closely you will find other traces of twelfth-century work. There is nothing complete, but you will find blocked doorways, parts of arches and pieces of decorative sculpture, in particular two blocks on the chancel walls that once received and supported the ends of an arch, carved with Romanesque scallops in relief.

The highlight of Hook Norton, though, is the font, probably made in the 1120s, situated just inside the south entrance door. It is bucket-shaped, made of creamy oolitic limestone (likely from the Chipping Norton area), and carved with an assortment of figures and scenes in shallow relief, some with words

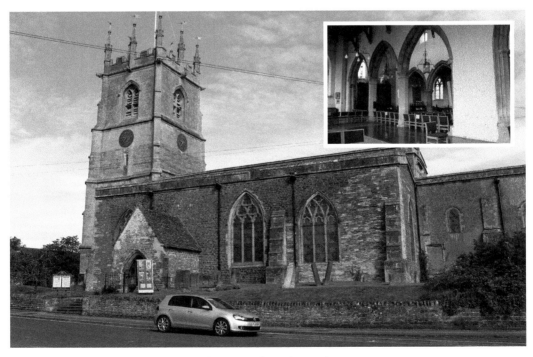

Exterior of St Peter's Church, Hook Norton, from the south.

*Inset*: Nave interior, looking north-west.

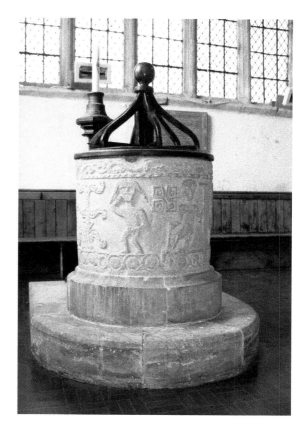

The font.

inscribed. Adam and Eve, present to remind us of the Fall of Man from which we are redeemed by baptism, are carefully named. Adam holds a rake and Eve carries an apple and a fig leaf, indicating that they have been banished from the Garden of Eden, represented by a depiction of the Tree of Knowledge next to Eve. Further round the font are three figures from the Zodiac (Sagittarius, Aquarius and Leo), and the mythical beast known as an amphisbaena, with an animal's head and front legs, a serpent's body, and a tail ending in another head, which the creature grasps. Any spaces on the font's surface are filled with ornamental designs. Many sculptured Romanesque fonts survive, but this one is particularly lively and engaging in its detail, and has no known parallels. It forms no part of an identifiable group, and we have no idea of the sculptor's identity.

## 23. St Mary's Church, Iffley

St Mary's, standing proudly in an east Oxford suburb, is probably the most famous Romanesque church in Britain, noted for its abundant coverage of decorative and figurative sculpture. The lord of the manor in the late twelfth century was Robert de St Remy, and by a slightly circular argument the church is attributed to his patronage, *c.* 1180. The plan, of aisleless nave and chancel separated by a heavy square central tower, looks like a throwback to Anglo-Saxon churches, but there

was, apparently, no predecessor on this site. It survives remarkably intact, though post-medieval interventions and the passage of time demanded restoration in the nineteenth century. This was luckily carried out by a succession of sensitive and scholarly architects, who strove to reinstate as much as possible of what had been lost, mostly at the upper levels. A more unfortunate, but perhaps necessary, intervention has been the recent limewashed shelter coat on the west front and south doorway – a startling shade of buttermilk.

Think Iffley and you think chevron, the patterns of multiple zigzags that adorn doorways, arches and vault mouldings alike. The west door, beneath a restored circular window, has continuous orders without capitals, the inner one being chevron, but the two outer ones another form of mature Romanesque decoration, the beakhead. These heads, with two large eyes and a beak gripping a roll moulding, are splendidly sinister, and probably performed an apotropaic function, warding off evil. The surrounding hood mould has small reliefs of monsters and signs of the Zodiac in beaded frames separated by gripping lion heads, a motif familiar from illuminated manuscripts.

The north and south doors provide further kinds of decorative work, scalloped capitals, big rosettes, and, on the south, figured capitals, including a depiction of Samson breaking the jaws of the lion. A corbel table runs round the eaves, mostly uncarved, which has led to suggestions that it was carved in situ. Given the

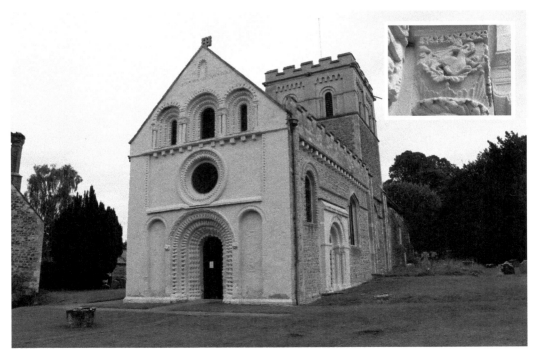

Exterior of St Mary's Church, Iffley, from the west.

*Inset*: South door, capital showing Samson and the lion.

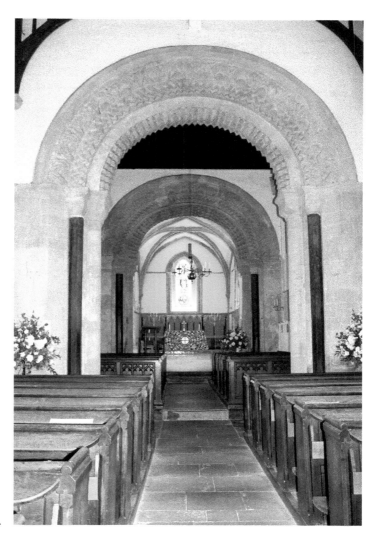

Interior, looking east.

dangers of carving at high level, this is most unlikely; more probably the patron ran out of money, and uncarved blocks had hastily to be installed.

Inside, the west and east arches under the tower are richly carved in three orders on their west sides, facing the congregation. The inner orders are supported on polygonal columns made of dark, polished Purbeck stone, which was just coming into fashionable use. The two chancel bays are a contrast: the west bay is part of the original build, with heavy cross-ribs decorated in chevron meeting at a keystone carved with a dragon; the east bay, which possibly replaced a semicircular apse, was built in the thirteenth century, with a delicately moulded rib vault and lancet windows flanked by colonnettes.

After this, do not miss two modern stained-glass windows at the west end of the nave, by John Piper on the south and Roger Wagner on the north.

## 24. St Matthew's Church, Langford

Dedications to St Matthew, the Gospel writer, are rare in Oxfordshire and St Matthew's Church, Langford, lying close to the boundary with Gloucestershire, is one of the most interesting churches in the county. The landscape is flat here, heralding the headwaters of the River Thames, with scarcely a hint of the Cotswolds a few miles to the north. Domesday Book records the estate of an Anglo-Saxon landholder centred on Langford, and the earliest surviving parts of the church are built in that curious style, perhaps pre-Conquest or perhaps later in the eleventh century, which combines Saxon and Norman features, suggesting that the masons were Saxons who were absorbing new ideas from Normandy into their traditional methods. The window mouldings of the prominent central tower are Anglo-Saxon in form, as are the flat pilaster strips below them. The relief panel of the Crucifixion, reset over the porch doorway with St Mary and St John the wrong way about, facing away from Christ instead of towards him, have the soft drapery folds of the same era. On the east wall of the porch is another reset sculpture of the crucified Christ, headless and wearing a long robe. It is an unusual feature and associated with a miraculous figure at Lucca in Italy, similarly clad and very famous in its day. This one is also probably of the mid-eleventh century, but the date is disputed.

The tower arches, emphatically dividing the nave from the chancel, continue the Saxo-Norman theme. The one opening from the nave is heavy and plain with round arches and square jambs. The nave, though, is open and barnlike. The aisles were added about 1200 when Norman solidity was yielding to the more moulded, delicate Early English, seen in the arcades and the fluttering, varied foliage of the

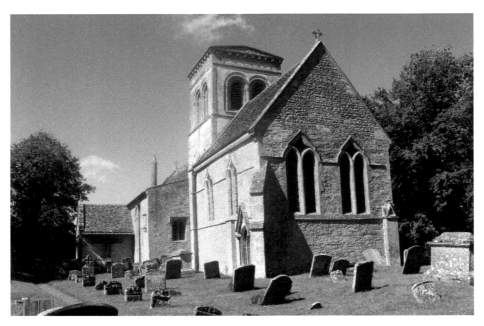

Exterior of St Matthew's Church, Langford, from the south-east.

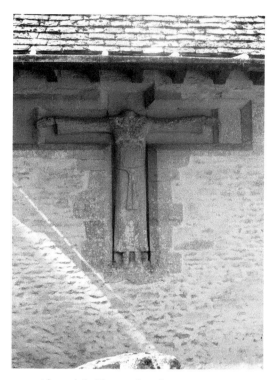

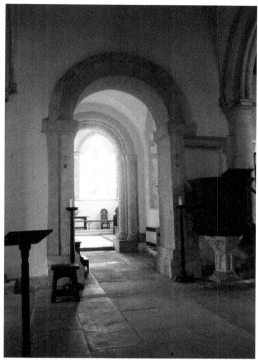

*Above left*: The rood sculpture.

*Above right*: The tower arch looking through to the chancel.

capitals. Soon afterwards the chancel was rebuilt. The concave lozenges of the windows are extraordinary: not a unique design but an extremely uncommon one, pierced above double lancets with pointed arches – observe the very shallow pointing of the window arches themselves. The chancel went through various stages of decay and restoration over the centuries, but one happy survival is the aumbry or cupboard on the north wall, which is not the expected small, square opening in the wall but a two-stage projection with six compartments under a triplet of gables.

## 25. ST MICHAEL'S CHURCH, LEAFIELD

Leafield lies within what was formerly part of Wychwood Forest, the great medieval royal hunting forest that stretched from Woodstock to Northamptonshire. The village is on high ground and the solid spire of the church dominates the view from several miles in all directions. Still very tall, the spire has been lowered twice since it was built.

Until the mid-nineteenth century Leafield was a chapelry to a neighbouring parish, so it was only from 1858 that it acquired its own parish church. The church, promoted by the efforts of the perpetual curate J. H. Worsley, was built by

James Thomas of Abingdon, but the design was entrusted to the great promoter of Gothic Revival, George Gilbert Scott. Scott was a perceptive and serious student of medieval Gothic architecture, and under the influence of Augustus Pugin he came to believe that Gothic was the true style for churches (a rule he also applied to his domestic buildings, as in the vicarage house in Leafield, which was built at the same time as the church). By the late 1850s he had come through early experiments with Gothic forms to full and persuasive confidence.

You approach the church from the west, and your first impression is of a façade that makes a fine frontispiece to the octagonal upper storey of the central tower and the spire. The west front has gabled door, flat buttresses and lean-to aisle roofs. Over the door is a roundel carved with good relief foliage, two tall lancet windows and a circular window with cusps, imitating the first attempts at window tracery made in the early thirteenth century. This elaborate ensemble does not prepare you for the relative austerity within.

The aisled nave leads to the chancel through the tower bay, which makes the chancel feel quite deep and distant. It has three tall eastern lancet windows, with a rose window above. In the nave solid, circular piers lead to plain arches supported on equally plain capitals, but look closely and details begin to come through. The

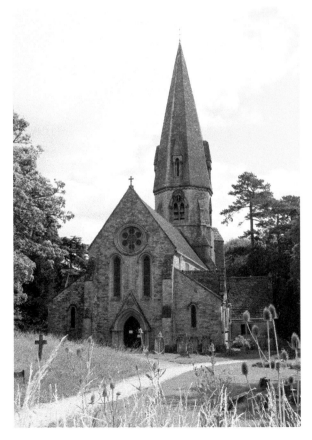

Exterior of St Michael's Church, Leafield, from the west.

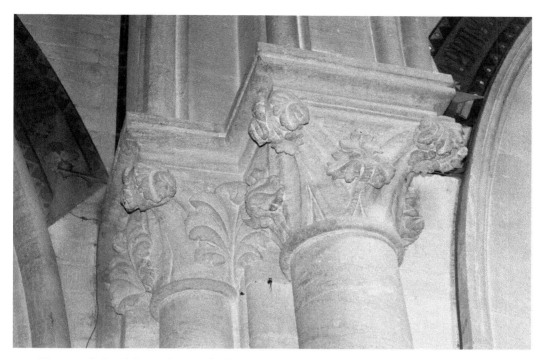

Tower capital and decorative metal strip.

pier bases are moulded in imitation of late twelfth-century designs, as are the tracery of the side windows and the beautiful foliage capitals in the tower bay, the only decorative carving in the church. The short clerestory windows are set deep behind small columns that suggest a wall passage. This all reflects just the moment when Romanesque designs were tipping over into early Gothic, and is done with Scott's full powers of observation.

Around the arches and on the chancel wall are strips of zinc painted with sacred texts, said to be the work of the curate's wife, Catherine. The lean-to timber frames of the aisle roofs are hipped up to clear the windows, a curiously domestic effect that anticipates much Arts and Crafts work in later decades.

## 26. St Margaret's Church, Mapledurham

The first thing you are aware of at Mapledurham is the sound of water cascading down the weir at the nearby lock on the River Thames. The church lies east of the mill, tucked into a corner beside the gates leading to the splendid Mapledurham House, built of brick in the late sixteenth century.

When he restored St Margaret's in 1863, William Butterfield (d. 1900) did homage to the house by facing the church tower in chequered brick and flint, and added a pyramidal roof. It is in any case a building of mixed materials with a stone south aisle and a flint and stone north wall, where Butterfield attached a wooden porch. Inside he created a north aisle by inserting an arcade of two timber

piers, decorated the tracery in the wooden medieval roof, and was presumably responsible for the coloured painted decoration of the font.

The font is an unusual one: a Romanesque tub shape with carved diagonal striped decoration; it is the oldest feature of the church, certainly predating the existing building. The church structure dates to the fourteenth and fifteenth centuries, and is fairly featureless except for the south aisle. The building is a former chantry chapel, built around the 1380s to house the tomb of Sir Robert Bardolf (d. 1395), the owner of Mapledurham, with a notably large memorial brass.

The Bardolfs were eventually succeeded as owners by the Blount family, and it is Richard Blount (d. 1628) who we see on the dominant double tomb between the nave and the Bardolf chapel, lying in effigy with his first wife, Cecily (d. 1619), a richly dressed couple as befitted the man who completed the house in 1612. Always Roman Catholic, the Blounts managed to negotiate their way through the Reformation and its aftermath, reserving the Bardolf chapel for their exclusive use, which is owned by their descendants and not the church.

The impression of a secret and rather special place is enhanced by a long approach down a narrow lane. The village that lies outside the gates consists of a few brick-built houses, including early seventeenth-century almshouses, and the mill, set back at the water's edge.

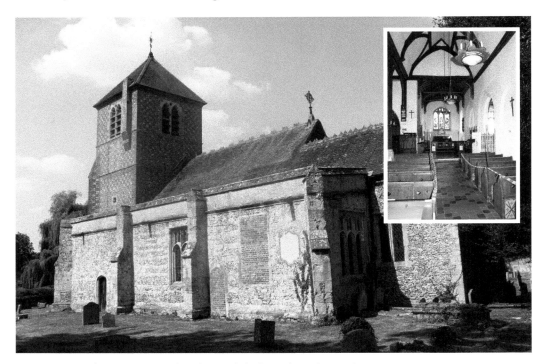

Exterior of St Margaret's Church, Mapledurham, from the south-east.

*Inset*: Interior, looking east.

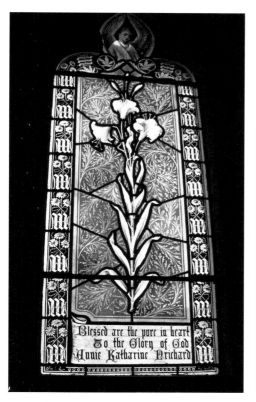

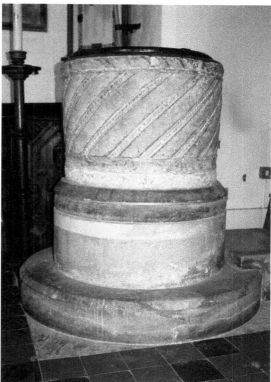

*Above left*: The lily window.

*Above right*: The font.

## 27. ST SIMON AND ST JUDE'S CHURCH, MILTON-UNDER-WYCHWOOD

St Simon and St Jude's is a fine Gothic Revival church, complete with its original furnishings. It was built in 1854 by George Edmund Street (d. 1881), architect of the Law Courts in The Strand, London. Street designed not only the church but its liturgical fittings, the lychgate at the entrance to the churchyard and the school next door. He was also architect to the diocese of Oxford, and his restoring hand may be seen in many local churches.

It is worked in a style that blends characteristics of the thirteenth and early fourteenth centuries, though you would never mistake this for a medieval church. The west wall, which, as at **Leafield**, is the first thing you see, has a strong central buttress with windows on either side and above it an octagonal turret with a small spire and bell openings. The Geometric window tracery and the mouldings are impeccably correct, but the buttress certainly is not, and like many Gothic Revival churches of this period the building feels almost too weighted to the ground.

Inside, you lose that feeling. The nave has piers of four shafts arranged in a quatrefoil, fronted by the thin strips known as fillets. The capitals and bases are moulded, the base mouldings resting on half-hexagons. The arch mouldings are broad, simple and slightly soapy in appearance. These and the bases, together with the continuous mouldings of the chancel arch, are derived from fourteenth-century buildings, while the piers and capitals are inspired by earlier ones, as are the supports to the wall posts of the timber roof, which are carved with naturalistic foliage. However, the small clerestory, set deep behind cusped arches, takes us straight into nineteenth-century medievalism and the five-light east window of the chancel is a creative form of Geometric.

It is rare for a complete set of original liturgical fittings to survive, but they do here: the stalls, the chancel screen and pulpit, the pews, the font and its cover are all by Street. The screen and pulpit are made of stone, which Street favoured particularly for screens; the screen has punched tracery, the pulpit is faced with Gothic panelling. The glazing of the chancel is later, installed by Kempe and Co. early in the twentieth century; and that in the east window of the south chapel is much more recent, made by David Wasley in 1985.

The lychgate shows another aspect of Street's style. He was a significant link between the early Gothic Revival and the nascent Arts and Crafts movement, and the hipped design of the lychgate roof hints at the latter.

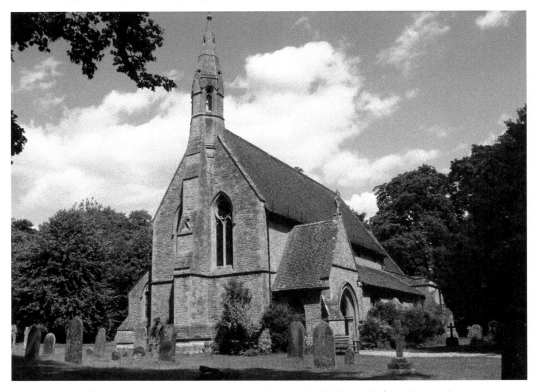

Exterior of St Simon and St Jude's Church, Milton under Wychwood, from the south-west.

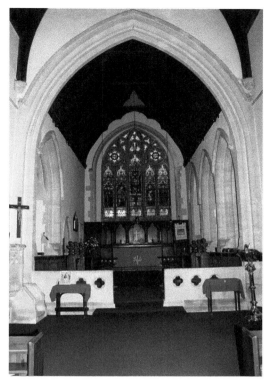
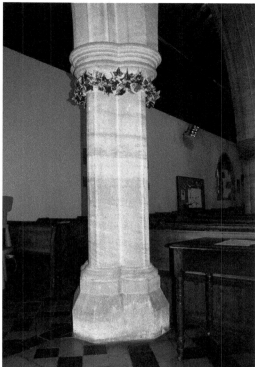

*Above left*: Chancel interior.

*Above right*: A pier in the nave.

## 28. St Mary's Church, North Leigh

Situated at the bottom of the hill below the village, St Mary's is a church of many periods, each part very good of its era. It seems at first sight to have a typically late medieval exterior, with a west tower, aisled nave and chancel with an attached north chapel, plus an extra north chapel off the nave that is clearly later than the rest of the building. However, even as you approach up the path from the east you can see a redundant roofline on the tower, and if you go round to the west end you will see traces of an earlier building. The lowest storey of the tower is Anglo-Saxon; there is another redundant roofline on this west face, with signs of possible north and south extensions on either side of the tower. Enter the church and examine the ground storey of the tower which, although plastered and whitewashed, has odd bits of arch and other masonry that also seem to hint at these extensions, although everything that is there now dates from the fourteenth century.

It seems that the original Anglo-Saxon church consisted of a single-cell nave and chancel separated by a central tower with projecting chapels known as *porticus*, a common form of pre-Conquest plan. Sometime towards the end of the twelfth century, as shown by the style of the nave capitals, the Anglo-Saxon nave was pulled

down, the chancel was replaced by the current aisled nave and south doorway, and a new chancel was begun east of it. In the chancel are two columns with moulded capitals that support nothing, and were perhaps intended for a new chancel arch. It is all pleasantly puzzling. Above the existing chancel arch is a fifteenth-century wall painting of the Last Judgement, which is difficult to decipher.

The two north chapels are much more consistent. The Wilcote chapel north of the chancel was built from the late 1430s by Lady Elizabeth Blacket (d. 1445) as a chantry chapel for her first husband and two sons. Her effigy lies beside that of her husband on the splendid chest tomb that fills the arch to the chancel on the south side. The chapel is roofed by a beautiful fan vault of two bays and lit by Perpendicular windows that occupy the whole space between the vault shafts. Lady Elizabeth had noble and ecclesiastical connections with both Warwick and Oxford, and many of the details here reflect buildings in both places. The fragments of stained glass in the east window contain single letters of the alphabet, which has led some people to suggest that the chapel was used as a school. The current altar, reredos and prayer stools were made in 1999 by Nicholas Mynheer.

West of the Wilcote chapel is the Perrott aisle, built as a family burial chapel in the late 1680s by James Perrott (d. 1724). The builder was Christopher Kempster, a mason and quarry owner in Burford, who supplied stone for Wren's St Paul's Cathedral. Its broad, generous proportions, the Tuscan Doric arcade, acanthus leaf decoration and big, round-arched windows make a nice classic contrast to the rest of the building.

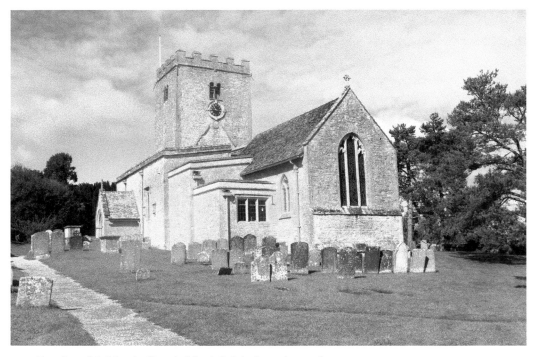

Exterior of St Mary's Church, North Leigh, from the south-east.

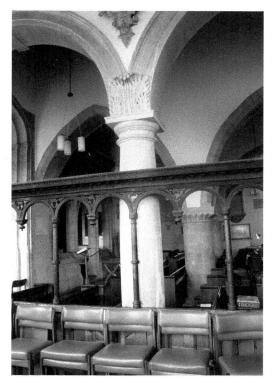
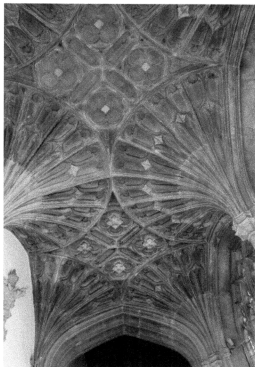

*Above left*: Interior looking south from the Perrott aisle.

*Above right*: Fan vault of the Wilcote chantry chapel.

G. E. Street restored the church in 1864–65. Among lesser details, he contributed the wooden barrel of the chancel roof, but more importantly the stone chancel screen with Gothic traceried decoration and the stone pulpit.

## 29. HOLY TRINITY CHURCH, OVER WORTON

Over Worton church stands outside the village, on the north-eastern edge of the Cotswold escarpment, looking down on to the plain towards Bloxham and Banbury. A path leads to it from the drive to three fine early nineteenth-century houses, one of which is the former vicarage. Its predecessor had the distinction of being the church in which the future cardinal and saint, John Henry Newman, preached his first sermon after his ordination (in the Church of England).

The church was, however, rebuilt in 1844–45 by the Oxford architect J. M. Derick for the then vicar, Revd William Wilson, whose family owned the large mansion to the south. It is a lovely example of early Gothic Revival in the scholarly style, its details consistently thirteenth century. The nave, with a south aisle, leads to the aisleless chancel, which ends at the east wall in three joined lancet windows with an echelon of blind lancets either side. Otherwise, the architecture is

plain, with moulded capitals and bases to the circular piers, and moulded consoles supporting the chancel arch. The wooden roofs are, however, supported on carved headstops. The two main ones facing into the nave are portraits of Queen Victoria and Prince Albert, a nice updating of the thirteenth-century habit of carving heads of kings and queens in that position.

The most striking sculpture is to be found on the font, a polygonal basin on a stem, the faces carved with circular bosses displaying foliage in relief. Again, the style is consistent with the architectural design, and it is evident that Derick, like his contemporaries George Gilbert Scott and Augustus Pugin, carefully observed the medieval models.

The effigy of a seventeenth-century lawyer lies a little incongruously at the east end of the south aisle, while at the west is the splendid timber organ case, carved in the reticulated tracery of the fourteenth century. It was built in 1847 and is the only fitting in the church not designed by Derick himself.

Go outside, admiring the golden-brown ironstone, and walk round to see the bulky tower built off to the north of the nave in 1849. It looks squat and rather heavy, but it was intended to have a spire, which was designed though never built. Derick's very beautiful drawing for the spire betrays his training in the drawing office of the architect Sir John Soane. The spire would have doubled the tower's height and balanced its thickness. The reason for a spire becomes obvious if you go to the edge of the churchyard and look northwards: in the distance is the spire of Bloxham. Away to the east stands St Mary's Church, **Adderbury**, another church with a handsome spire. Holy Trinity was intended to make a group of four spires with them and King's Sutton.

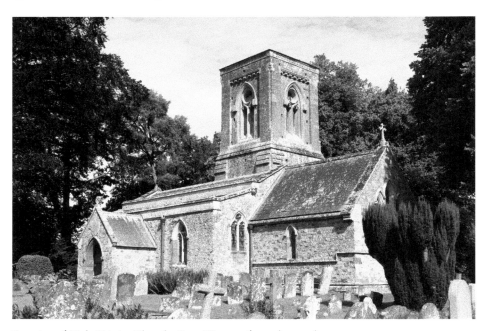

Exterior of Holy Trinity Church, Over Worton, from the south-east.

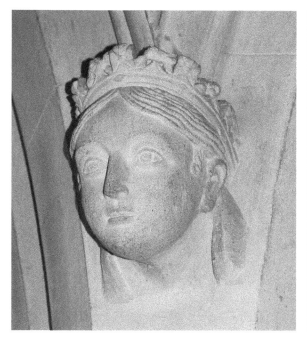

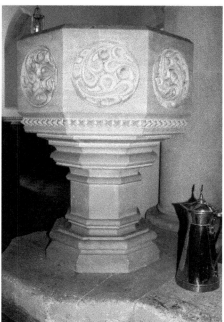

*Above left*: Head stop of Queen Victoria.

*Above right*: The font.

## 30. ST BARNABAS'S CHURCH, OXFORD

St Barnabas's Church was built in 1868/9 near the Oxford Canal in the district known as Jericho, which housed workers at the Oxford University Press. It is a surprising church to find in what was then a very poor area – large and based on early medieval Italianate buildings quite unfamiliar to members of the congregation. Vital to it was the patronage of Thomas and Martha Combe, supporters of the arts and the Oxford Movement, which sought a return to a more sacramental and focused liturgical practice. Combe appointed his friend Arthur Blomfield (d. 1899) as architect; support came also from Samuel Wilberforce, the Bishop of Oxford. It is fascinating to compare this church with St Mary's, **Banbury**, where Blomfield and Wilberforce were both involved in liturgical reordering.

The tall, two-storey Italianate tower of St Barnabas's is visible some way off, with the eastern apse jutting beside it. Blomfield, instructed to build soundly, wanted a concrete building, but mortared rubble was cheaper, with added brick courses to enliven the exterior. Inside, the walls are plastered. The wide, semicircular arcades, very reminiscent of early Italian Romanesque, stand on columns with capitals and bases that would not look out of place in an early Gothic church, with foliate spurs to the bases and capitals with layers of outward

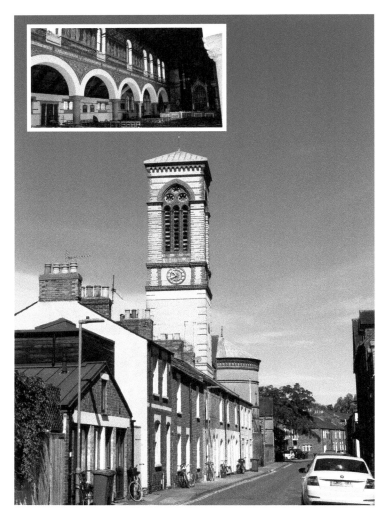

The tower of
St Barnabus's
Church, Oxford.

*Inset*: Interior,
north wall.

turning leaves through which the edge of the 'bell' is visible. Did Blomfield inspect the capitals in Oxford Cathedral? Yet alongside these creative responses to medieval styles, the aisles, with their lean-to wooden roofs and small rectangular windows, seem to anticipate the architecture of the Arts and Crafts movement, which is not surprising since everyone involved moved in Pre-Raphaelite circles.

   The font in the baptistry at the west end was designed by Blomfield, as were the pulpit and the splendid choir. The choir and apse have been modified several times, but the original spirit survives in the decoration of the apse with Christ in Majesty and the symbols of the Evangelists, and in the chancel. Unmarked by a transept, this arises at the end of the nave, surrounded by low barriers, just as in early Christian churches in Italy, and a very self-conscious touch in Britain. Since higher railings have been removed, this impression is now greater than it was originally. The altar canopy, however, is in Italian Gothic style.

The final Italianate touch is the decoration of the north wall, which was installed between 1905 and 1911. The row of standing figures between the windows and the blue foliage decoration between the arches immediately recall work in Ravenna, but here the glass mosaics represent the Te Deum rather than the emperor's court.

Portraits of the protagonists, including Combe and Wilberforce, are carved on capitals at the west; and the Combes are properly commemorated in a plaque on the exterior of the church.

## 31. ST MARY'S CHURCH (THE UNIVERSITY CHURCH), OXFORD

St Mary's is a prominent landmark on the High Street, with Radcliffe Square and the Old Bodleian Library to its north. From the thirteenth-century convocation the university's governing body met in the church, hence its name, and the fourteenth-century Convocation House partly survives on the north side, now used as a pleasant café. Otherwise, what you are looking at is a large, dignified church in the Perpendicular style of the fifteenth century with an earlier tower offset on the north side and a wholly surprising south entrance porch decorated with twisted barley-sugar columns. This was built in 1637 by the mason John Jackson, the columns imitating the early Christian ones round the high altar of St Peter's in Rome; but notice the contemporary fan vault within, a reference to a former era.

The fourteenth-century spire dominates all views of St Mary's, and though it was modified by restoration, it is still a fine example of the Decorated style, anchored to its supporting tower by aedicules and pinnacles, and much adorned with the ubiquitous ballflower, a composition of three simple lobes meeting above a small

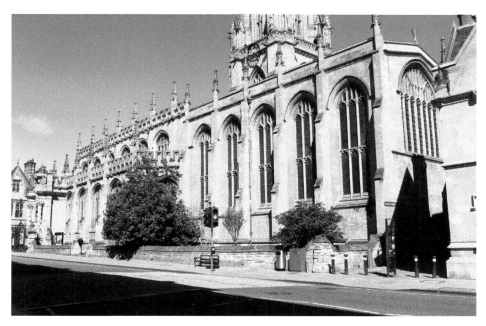

St Mary's Church, Oxford, the exterior from the south-east.

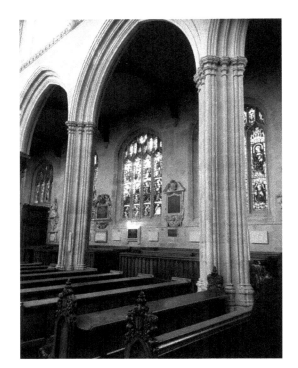 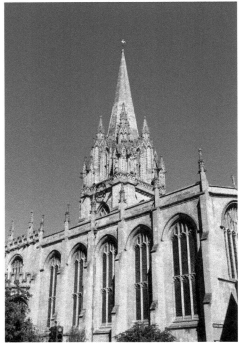

*Above left*: The nave arcade.

*Above right*: The spire of St Mary's.

ball. The church over which the spire presides is much more sober, presenting an orderly succession of large Perpendicular windows below a battlemented parapet with yet more pinnacles, concealing the shallow-pitched roof. On the north side of the church is the Brome chapel, built in the 1320s by Adam de Brome, founder of Oriel College. This chapel must be about the same date as the tower and spire, but the late fifteenth-century rebuilding of the main church forced the chapel outwardly to conform to the new style with a set of new windows.

The chancel was rebuilt *c*. 1463 and the nave from *c*. 1488, the interiors of which are lofty, light and, at present, a little remote in character. Yet its grandeur is impressive and peaceful, partly owing to the window tracery: the chancel, the nave aisles and the clerestory each have their own, discrete pattern, uniform at that level but not repeated elsewhere, so that the building seems to unfold calmly before you. The chancel is a single cell, like a college chapel and with the same tall windows above the stalls, the east window raised high to accommodate an elaborate altar screen beneath it. The nave arcade is quite sharply pointed for its date, with three clear orders of mouldings matched by the supporting shafts on the piers; the clerestory windows are huge, stretching almost the full width of the bay. After the porch, you might expect a vaulted interior, but the roofs are timber with arched tie beams.

## 32. ST NICHOLAS'S CHURCH, ROTHERFIELD GREYS

This is now a small nineteenth-century church with an early seventeenth-century north chapel. Traces of its medieval past are revealed by a blocked twelfth-century door on the north side of the nave, the contemporary font, and the thirteenth-century wall cupboard and piscina in the chancel. This modest little building, however, houses two memorials that are worth the journey.

In the floor of the chancel is the magnificent memorial brass to Lord Robert de Grey (d. 1387): 148 cm long, an armed figure with a helmet and sword, hands at prayer and its feet on a cheerful lion, set within a pinnacled canopy topped by a tall ogee arch. Lord Robert was the last of the male line of a family that had built Greys Court, and lived there since the eleventh century. This is a well-preserved brass and gives a good idea of the original appearance of the damaged Bardolf brass at nearby Mapledurham.

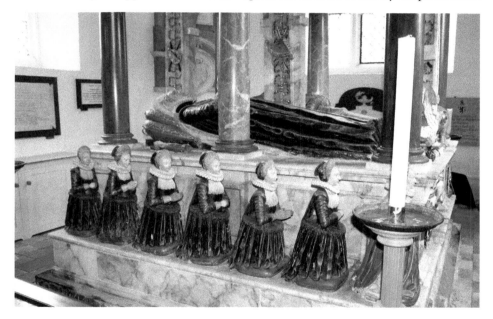

*Above*: The Knollys tomb with weepers on the south side in St Nicholas's Church, Rotherfield Greys.

*Right*: Sculptured ensemble atop the Knollys tomb.

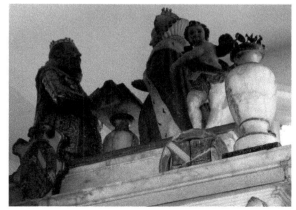

Successors to the Greys were the Knollys family. It was Sir William Knollys, 1st Earl of Banbury (d. 1632), who built the north chapel in 1605, as a memorial to himself and his father. The huge tomb that occupies much of the space commemorates Sir Francis and Lady Knollys (d. 1596). It is an opulent form of freestanding canopy tomb, the two effigies lying on an imposing tomb-chest and their children kneeling alongside as weepers in attitudes of prayer. Pale alabaster contrasts with various marbles used for the columns that support the heavy canopy, on which kneel representations of Sir William and his first wife, who died childless the year the tomb was made. They share the canopy with corner urns, prancing cherubs and the shield of family arms.

Everything is richly detailed and grand. The kneeling weepers are shown much larger than is usual in this type of tomb, their features and mourning garments carefully detailed. Much original paint survives, the black clothes of the effigies and the weepers setting off scarlet cushions, Lady Knollys's rich red cloak and Sir William's armorial surcoat. A sombre note amid all this ostentation is in the figure of the child that predeceased the parents, a tiny scarlet parcel lying at its father's shoulder. There is something almost shocking in encountering this outstanding monument in such a commonplace, if pleasant, building.

## 33. CHAPEL OF ST MICHAEL, RYCOTE

The chapel of St Michael at Rycote is a small miracle, both inside and out. It was founded in 1449 as a chantry chapel by the local lord, the merchant Richard Quatremain, and his wife Sybil, who are entombed in **Thame** church. It stands in the grounds of a former Tudor mansion with medieval antecedents and is a

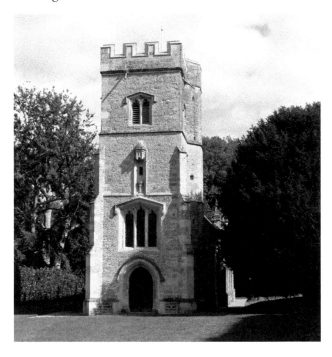

The west tower of Rycote's Chapel of St Michael.

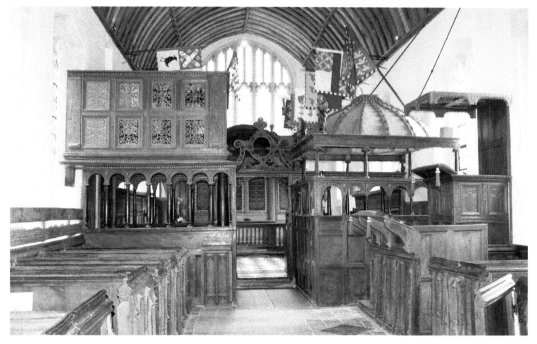

*Above*: Interior, looking east.

*Right*: Lord Williams's heraldic dog.

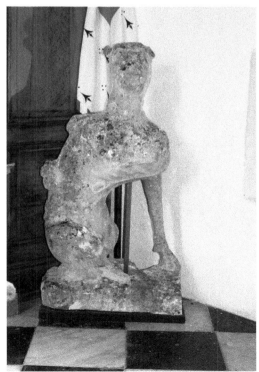

rectangular box with continuous nave and chancel, fronted by a west tower, all consistently Perpendicular in style, regular and slightly stiff, articulated at intervals by buttresses with pinnacles. Later owners, Lord Williams of Thame (also entombed at Thame) and the Norreys family, have left their mark: Lord Williams by placing two heraldic dogs on the east gable, now replaced, with the weathered originals brought inside for safekeeping.

Inside, the chapel is roofed by a long wooden barrel vault, once painted with stars, and carefully restored in the twentieth century when the chapel had become dilapidated. What was once a Roman Catholic foundation to pray for the founders' souls is now firmly Protestant in appearance, full of its post-Reformation changes, all of which have survived. Only the congregational pews date from the fifteenth century, along with the curious font. Almost everything is made of timber: the square pulpit is Jacobean, the reading desk eighteenth-century, and the altar reredos, with Corinthian half-columns, texts and fruit carvings, was made in 1682.

The first things you will notice, however, are the two huge seventeenth-century pews on either side of the aisle at the entrance to the chancel area. They are not documented, but tradition ascribes the north one to the Norreys family, and the southern pew to the visit to Rycote made by Charles I in 1625. They stand on the site of the former rood screen and incorporate some of its elements. The Norreys pew is surmounted by a musicians' gallery encased in panels of delicate openwork tracery, feathery light in contrast to the arcading below. The south pew has an arcade topped by a colonnade. Above this is a wooden onion dome ribbed with medievalising crockets and standing figures at the corners. The two pews together are a visual delight.

## 34. St James's Church, Somerton

Somerton is a hilly village on the bank of the River Cherwell, an idyllic prospect of riverboats, cattle, fields and trees. The church is a curious mixture of ironstone and paler limestone, with ironstone predominating. It is dominated by its battlemented parapets at every level, which, with a huge rectangular Perpendicular window in the south wall of the nave, would make you think it was a fifteenth-century church, until you notice a blocked Romanesque door and a good many fourteenth-century windows with flowing tracery. In other words, St James's has a long building history with many interventions and additions.

The aisled nave has a thirteenth-century north arcade of cylindrical piers on square bases with plain moulded capitals and chamfered arches, all of ironstone so pleasantly golden brown. You notice the difference on the tower, which displays a fourteenth-century relief of the Crucifixion carved in limestone. The truncated south arcade was built in the fourteenth century. The interior feels abundantly screened: the restored chancel screen is fifteenth century, its combination of Perpendicular panelling and swirling mouchette wheels indicating a south Netherlandish origin; the two screens on the southern side are late fifteenth century (in the nave) and seventeenth century (in the chancel). Before going into the big chapel on the south side, examine the stone reredos set into the wall behind the altar: a fourteenth-century relief of the Last Supper with the heads and torsos of Christ and the Apostles, each under his own little ogee arch. They are full of animated gestures and the sculptor has paid attention to their food and drink.

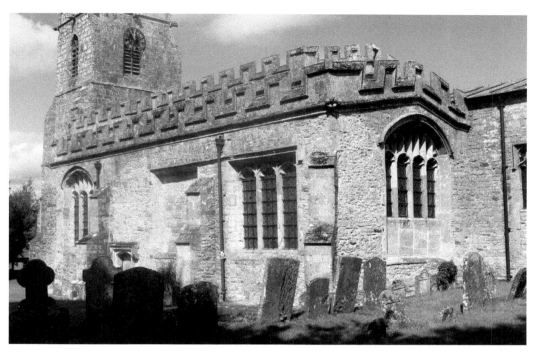

*Above*: South aisle exterior of St James's Church, Somerton.

*Below*: Detail of the Last Supper reredos.

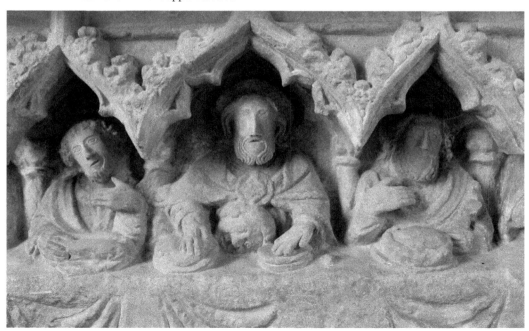

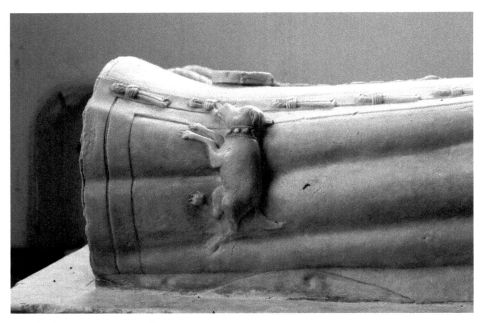

Detail of Brigitta Fermor's effigy.

The big chapel that occupies the south aisle was converted into a chantry by the Fermor family in the early sixteenth century, and several members were commemorated down to the nineteenth. Together they amount to a lesson in styles of tomb sculpture from early modern times. The alabaster effigies of Thomas and Brigitta Fermor lie on a chest tomb made in 1582, stiff and chilly but enlivened by the little dog that pulls on Brigitta's dress. West of them is the canopy tomb of Richard Fermor (d. 1642), another stiff effigy stretched upon a chest tomb with dark marble panels and dark Corinthian columns flanking a coffered arch surmounted by a deep square cornice supporting an elaborate coat of arms in a scrolling frame. Small obelisks stand above the columns. The Fermor tombs all represent the last gasp of opulent medieval tomb design, reserved in the Middle Ages for the higher aristocracy, later adopted by people of lesser rank. All the elements, except perhaps the effigies, are brought up to stylistic date. These tombs, like similar ones elsewhere, hint above all at a family's ancient lineage.

## 35. St Peter ad Vincula, South Newington

This church's dedication, to St Peter in chains, is uncommon. Perched in the main village above the busy A361, this building, like many village churches, looks late medieval on the outside and much earlier on the inside. The tower and porch were built around 1300 and the clerestory was added in the fifteenth century, but the central part of the nave is clearly Romanesque, with extensions and alterations in the thirteenth and fourteenth centuries. Architecturally, it is quite mixed then, but the main reason for visiting St Peter's is its extensive wall paintings, which have been recently conserved.

They seem to have been painted in three phases. The earliest, probably *c.* 1330, are in the north aisle. The murder of St Thomas Becket, a popular subject for paintings, reliquaries and church dedications, is depicted almost opposite the south entrance door, so it may be the first thing you see as you come in. Next to that is another murder scene: allegedly that of Thomas of Lancaster in 1322. He was Edward II's rebellious nephew and a short-lived cult grew up around his memory, but there is no evidence that he is the subject of this painting. Further east are superb depictions of, among other people, the Virgin and Child, donors, and St Margaret of Antioch, all shown in a swaying pose with gracefully falling draperies. They are painted in an oil medium, which had been used for high status wall paintings in England since at least the thirteenth century, and together with the rich palette of reds and greens, this suggests that the patrons – perhaps Thomas and Margaret Giffard – had access not only to money but to well-trained, metropolitan painters.

There may be traces of an Annunciation to the Virgin on the chancel arch, either side of the big Last Judgement painting. This is now incomplete, but the excellent explanation boards provided in the church are a great help with identifying scenes and people, and show the discoveries made by the most recent conservationists. Persistence, with binoculars, is well rewarded. These paintings are dated to the mid-fifteenth century; some years later a Passion cycle was painted above the north arcade of the nave. These are cruder in style than the earlier works, attributed for this reason to a local painter. The scenes, from the entry to Jerusalem at the west, are vigorous and easy to make out, appropriately finishing at the east end next to the chancel arch with a scene of St Michael weighing people's souls at the Last Judgement.

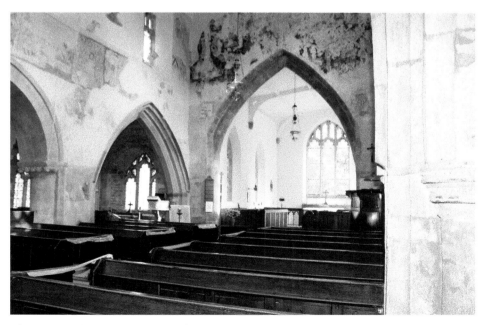

The interior of the Parish Church of St Peter ad Vincula, South Newington, looking north-east.

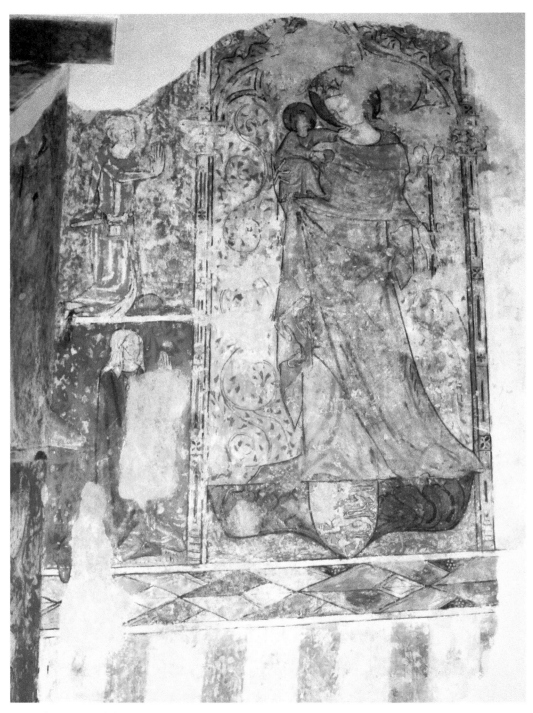

The Virgin, Child and donors.

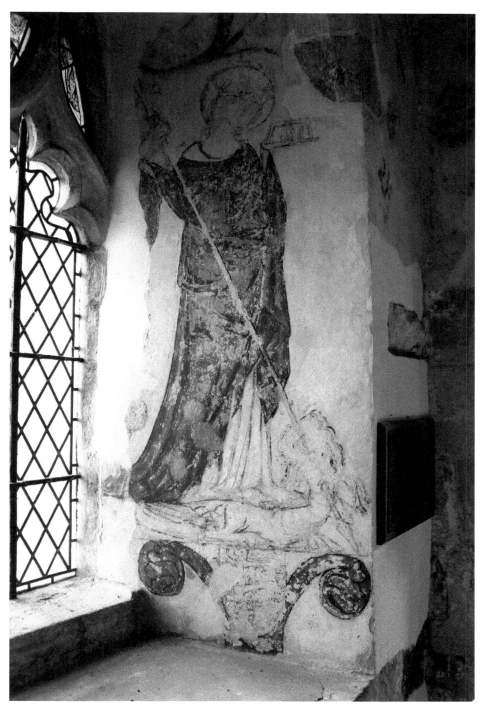

St Margaret of Antioch.

## 36. ALL SAINTS' CHURCH, SPELSBURY

Spelsbury church, with its squat, square west tower looks medieval both inside
and out; but although the nave arcade was built in the thirteenth century, the
remainder is the result of clever medievalising alterations and additions made
in the eighteenth and nineteenth centuries. The chancel was rebuilt in the mid-
nineteenth century with blind arches in its side walls intended to frame the glory
of the church: the astonishing tombs of the Lee family, later earls of Lichfield, who
owned nearby Ditchley Park. Members of the Dillon family, who succeeded to
Ditchley, are also commemorated in the church, most notably Charles, the 14th
Viscount (d. 1865), whose tomb in the north chapel of the church is a very fine
example of Gothic Revival work, designed by G. F. Fuller.

The four tombs in the chancel range in date from the seventeenth century to
the late eighteenth. Each is a wonderfully extravagant celebration of death, the
epitaphs characterising the occupants with all possible virtues – though in some
instances these were absent in life – and the carved details reward close study.

The alabaster effigies of Sir Henry Lee (d. 1631) and his wife Eleanor occupy
a fine canopied tomb of a type that goes back to the thirteenth century, its basic
form a tomb-chest with effigies and a surmounting canopy. Essentially a small
piece of architecture, this tomb type always reflects the period to which it belongs,
so here we are looking at the features of a Jacobean building and effigies dressed
in contemporary fashion. The tomb, designed by leading tomb maker Samuel
Baldwin of Gloucester, is made of alabaster, black polished marble, paint and

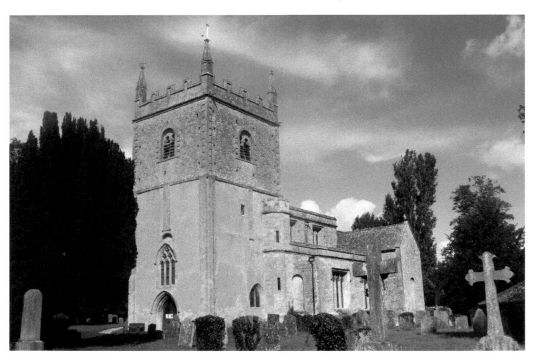

Exterior of All Saints' Church, Spelsbury, from the south-west.

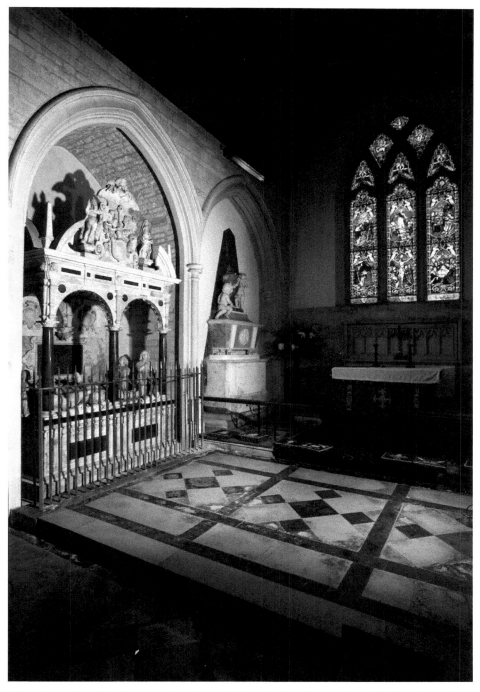

Chancel, tombs of Sir Henry and Lady Lee (left) and the 4th Earl of Lichfield (right). (Photo courtesy All Saints PCC)

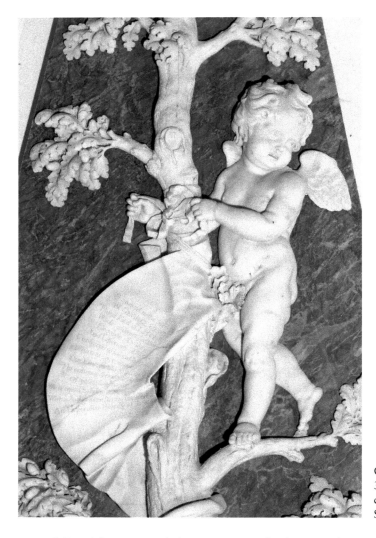

Chancel, tomb of the
3rd Earl of Lichfield,
detail. (Photo courtesy All
Saints PCC)

gilding. The armorials leave us in no doubt as to the occupants, and allegorical
figures of Time and Death atop the canopy perhaps encourage our reflections as
well as prayers.

The tomb of Edward Lee, 1st Earl of Lichfield (d. 1718), a marble panel set on
a black plinth, looks more restrained until you notice, rising from the frame to
the inscription, palm fronds, human skulls, bats' wings and two weeping cherubs
flanking the earl's coat of arms.

With George, 3rd Earl (d. 1772), the neoclassical style has arrived. This tomb
was designed by Henry Keene, surveyor to Westminster Abbey, and carved by
William Tyler, a founder member of the Royal Academy; their combined talents
are well on display here. The three-dimensional lower part, white marble topped
by a yellow marble openwork niche containing two classical urns, contrasts with
the flat, grey pyramidal panel above and behind it, background to a white marble

oak tree draped with a scroll held by a cherub. Snakes curling around the opening to the niche symbolise immortality.

William Tyler was also responsible for the fourth tomb, that of Robert, 4th Earl (d. 1776), and last of the line. Tyler used the same combination of white and yellow marble, adding red jasper from Sicily for the urn, which is supported by two charming cherubs who drape it with a garland.

## 37. St Michael's Church, Stanton Harcourt

St Michael's stands only metres away from the remains of the medieval manor house that belonged to the Harcourt family, several of whom are remembered prominently in the Harcourt chapel, which was built in the fifteenth century on the south side of the chancel. This provides a Perpendicular counterpoint to the Norman nave and the Early English chancel. The bulky, square central tower has a twelfth-century lower storey with the upper storey added by the Harcourts when they built their chapel.

The church was probably built by 1135, when it is first documented. Plain, round-headed Norman windows open in the north wall of the nave, which has a doorway with moulded arches and scallop capitals. The south door is more ornate, the arch decorated with continuous circular discs as well as scallop capitals. In the thirteenth century the transepts were added and the chancel rebuilt and enlarged with lancet windows – the three on the east wall defined by an arcade with capitals. The chancel screen is coeval with the building, a rare survivor from the thirteenth century. Another rare survivor, and a gem of its kind, is the stone base that supported the reliquary shrine of St Edburga of Bicester, brought here by Sir Simon Harcourt after the dissolution of Bicester Priory in the 1530s. The reliquary was destroyed, but the base, installed on the north side of the chancel, is fine Decorated work of the 1300s, carved of Purbeck marble with much surviving colour. An open structure with neat little vaults inside, it is fronted by ogee-headed arches on tall square uprights with shields of arms of prominent patrons of Bicester Priory between them. Small figures stand in corner niches, and heads and foliage adorn the capitals and the stringcourse at the top.

The Harcourt chapel once opened from the chancel through large arches, now blocked, with another entrance off the south transept. It was founded as a chantry chapel, with a priest retained to pray for the souls of the Harcourt family. Flooded with light from the Perpendicular windows, which occupy most of the upper wall space, the chapel now houses four tomb-chests with effigies and several wall monuments in a stunning display in which piety is mingled with family pride. South of the altar lie Sir Robert Harcourt (d. 1470/1) and his wife Margaret, the likely builders of the chapel, and opposite them on the north is their grandson, another Robert, whose tomb is a bit of a mishmash. Armoured and military, these figures were rather garishly painted in the nineteenth century. The two western tombs are medieval-revival memorials to the 2nd Earl, on the north, and Edward Vernon Harcourt, Archbishop of York (d. 1847) on the south.

Without being especially large or imposing, Stanton Harcourt is endowed with a special dignity, its harmonious proportions conveying a sense of gentle well-being.

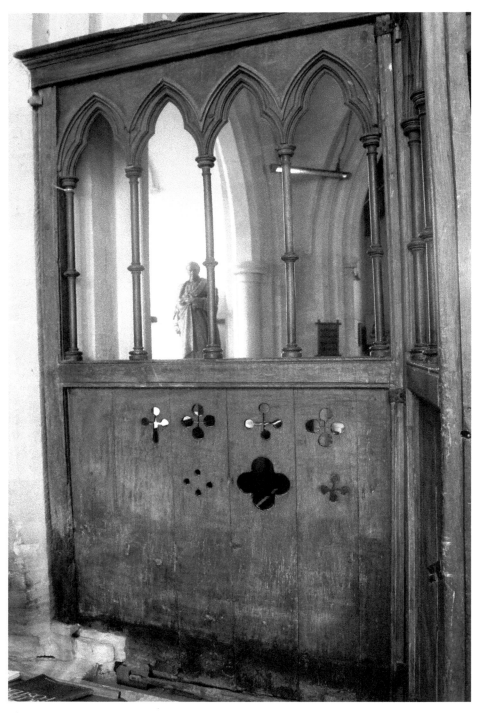

The choir screen, St Michael's Church, Stanton Harcourt.

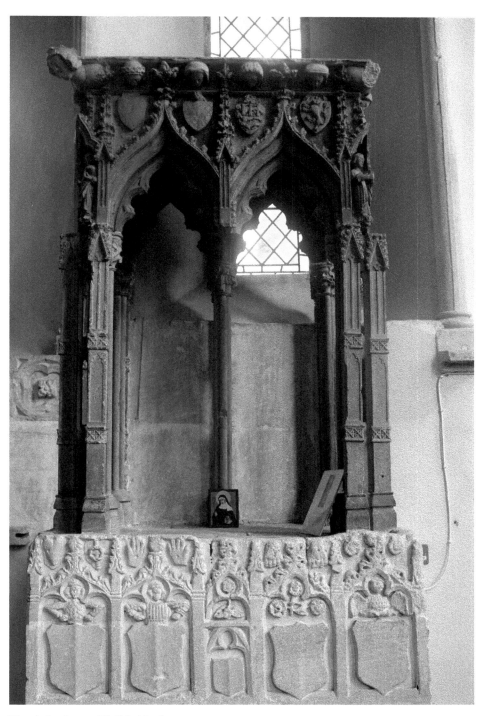

The shrine base of St Etheldreda.

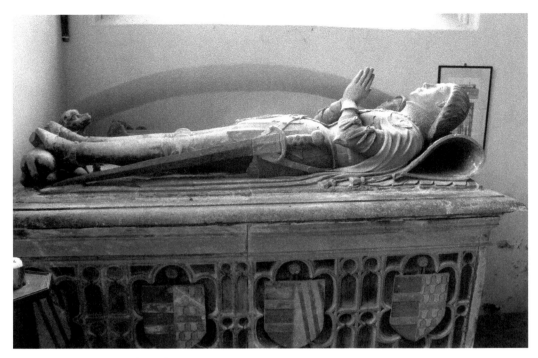

Harcourt chapel, effigy of Robert Harcourt.

## 38. ST MARY'S CHURCH, SWINBROOK

Swinbrook, on the River Windrush downstream from Burford, is forever associated with the Mitford family, several of whom are buried in the churchyard or commemorated in the church. Inside the church, however, it is another family that catches your eye: the Fettiplaces.

In the late medieval and early modern period the Fettiplace family was enormously successful, owning extensive lands in Oxfordshire and neighbouring counties, and six of them are depicted in wall monuments that once seen are never forgotten.

Swinbrook is a straggly village, spread intermittently along a twisting, narrow lane. The church occupies a hilly site above the lane, more or less in the middle of the main group of houses; cars can be parked behind it. It has a nave with aisles and a chancel, all modified with new windows in the fourteenth and fifteenth centuries. The odd little west tower was built in 1822 and looks far too small for the church. The nave interior dates from the later twelfth or even the early thirteenth century, with beautiful foliage capitals with stylised leaves that are almost beyond Romanesque, and some plain mouldings that speak of the same period. In the east window of the south aisle are fragments of medieval glass that somehow survived the Puritan destruction of the sixteenth and seventeenth centuries.

The Fettiplace monuments occupy the north wall of the chancel, two tall arches flanked by freestanding columns. The earlier one, to the west, was

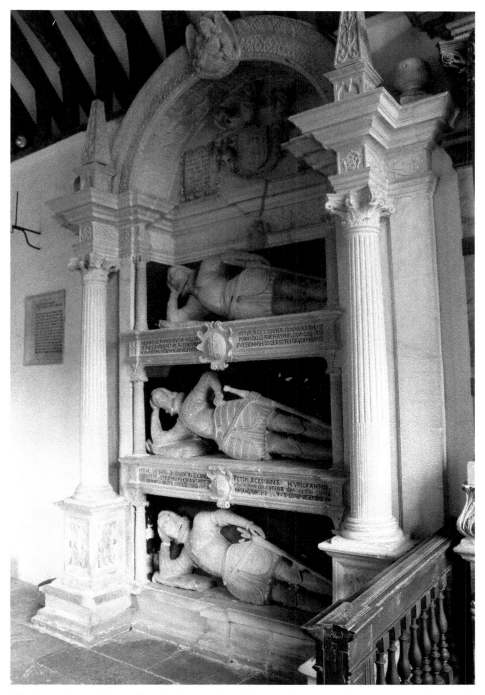

The chancel at St Mary's Church, Swinbrook, with an early seventeenth-century Fettiplace tomb monument.

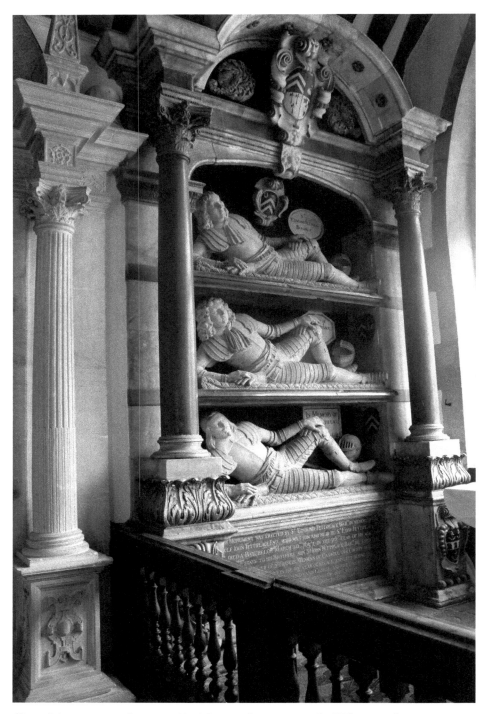

Chancel, late seventeenth-century Fettiplace tomb monument, by William Byrd.

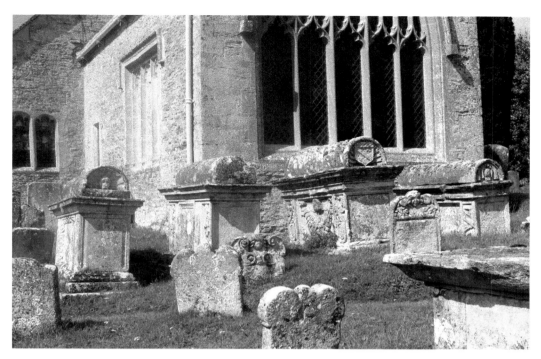

Bale tombs outside the east end.

built for Sir Edmund Fettiplace (d. 1613); the later one, eastward, for another Sir Edmund (d. 1686). Each is fitted with three shelves on which repose their sculpted occupants. Sir Edmund, William (d. 1562) and Alexander (d. 1504) lie stiffly on their sides, dressed in full armour and propped by one elbow on a cushion, as if beginning a Pilates exercise; the later Sir Edmund, John (d. 1672) and John (d. 1657) are more comfortably posed – still propped on an elbow but slightly turned and with one knee up. They are so enchanting that it is easy to overlook the classicising details of the architecture, their comparisons and their contrasts: much more colour was used in the late seventeenth-century group, with gilding and coloured marbles. This later tomb is signed by William Byrd of Oxford, whose work can also be seen at **Thame** and **Wantage**.

Just outside the porch and in front of the east wall are some fine bale tombs, with decorated chests topped by a bale, a series of linked half-hoops that may represent a funerary bier, a type that is particularly found in the Cotswolds. The one by the porch, with a barely legible inscription, is so placed as to catch the attention and hoped-for prayers of the congregation as it passed in and out of church.

A short walk through the fields beside the Windrush brings you to the tiny church of St Oswald, Widford, built over a Roman mosaic pavement and containing fourteenth-century wall paintings.

## 39. ST MARY'S CHURCH, THAME

Thame is an urban church, situated off the High Street, big and imposing, with a solid central tower. It may well have been a centre of Saxon mission, but what we are looking at belongs to the thirteenth century and later, when Thame was a flourishing market town.

In the Middle Ages Oxfordshire belonged to the diocese of Lincoln, and it was the bishops of Lincoln who built the church in the thirteenth century; but later on, with a change towards more lay involvement in church buildings, urban churches were often rebuilt or added to by rich townspeople who wanted altars and chantry chapels dedicated to prayers for their souls. It was they who paid for the later medieval alterations at Thame.

The church interior is wide, open and rather scraped, owing to a major restoration in the 1890s. The nave arcade of quatrefoil piers with moulded capitals and bases, and the row of lancet windows in the north wall of the chancel are the clearest signs of the thirteenth-century work. The capitals supporting the tower are of the same period, but when the tower was increased in height in the fifteenth century the tower piers were encased in a sheath of masonry to add strength. The window traceries, from Decorated through to the handsome Perpendicular end windows of the transepts, show how the church was embellished in the later Middle Ages.

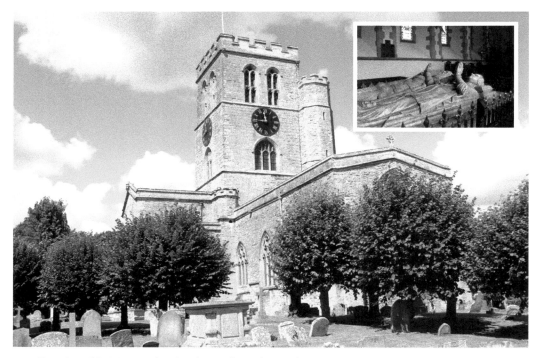

Exterior of St Mary's Church, Thame, from the south-east.

*Inset*: Chancel, effigies of Lord and Lady Williams.

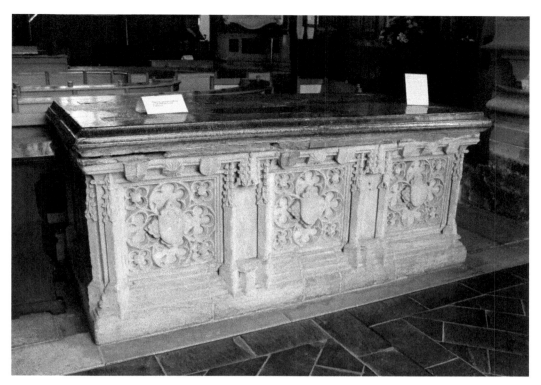

The Quatremain tomb.

Yet the contents of Thame church perhaps transcend the architecture. It is a building that invites you to potter about and discover things. The north transept screen and the rood screen are worth close examination, the rood screen possibly made by the same craftsmen as the screen at **Charlton-on-Otmoor**. In the chancel the choir stalls are partly sixteenth century. The space is dominated by the tomb of Lord and Lady Williams of Thame; Lord Williams (d. 1559) endowed the grammar school and almshouses, and this opulent tomb reflects his benefactions. The effigies are carved in exquisite detail; the unicorn and greyhound at their feet were added by William Byrd of Oxford after the tomb was damaged in the Civil War of the 1640s. Other works by the prolific Byrd are at **Swinbrook** and **Wantage.**

There are many memorial brasses in the church. Two are set in the tomb of Sir John Clerke (d. 1539) on the south wall of the chancel, a late form of the chest-and-canopy type that had such a long history. Other brasses to note are those of Richard Quatremain (d. 1447), his wife and Richard Fowler, his heir and perhaps godson. These are set on top of the big chest tomb in the south transept, where Quatremain founded a chantry. The owner of nearby **Rycote Park,** Quatremain was typical of the wealthy merchant class that was seeking social preferment.

## 40. ST MARY'S CHURCH, UFFINGTON

Uffington village lies more or less at the feet of the famous Uffington White Horse, engraved into the downland chalk. The church is on a grand scale for a village church; it stands out prominently when seen from the White Horse and would have been even more conspicuous before its spire fell in the eighteenth century. What you see is an apparently perfect, textbook example of an Early English building of the mid-thirteenth century – grouped lancet windows and refined mouldings, on a cruciform plan with a massive octagonal central tower. What you get is rather more complicated.

Some features of the plan are almost unheard of in a parish church: small chapels open off the east sides of the transepts, and the south porch of the nave is as imposing as any entrance to a cathedral. The small doorway under a gable in the south transept hints at a private entrance, but attempts to suggest a monastic function connected to the church's then owner, Abingdon Abbey, are not persuasive, owing to the lack of evidence of any close involvement. What is obvious, though, is the high standard of craftsmanship within the building. The lancet windows are grouped in twos and threes, outlined by mouldings and stringcourses. In the south wall of the chancel beside the altar are the sedilia under a beautiful moulded arcade in keeping with the other decorative work, although there are some corbel heads. The roofs are wooden, mostly restored, but with timber corbel heads supporting the wall posts in the north transept.

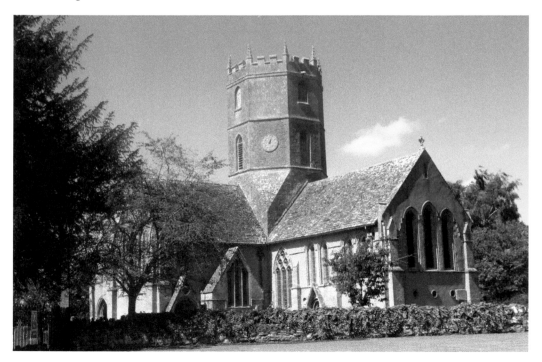

Exterior from the south-east

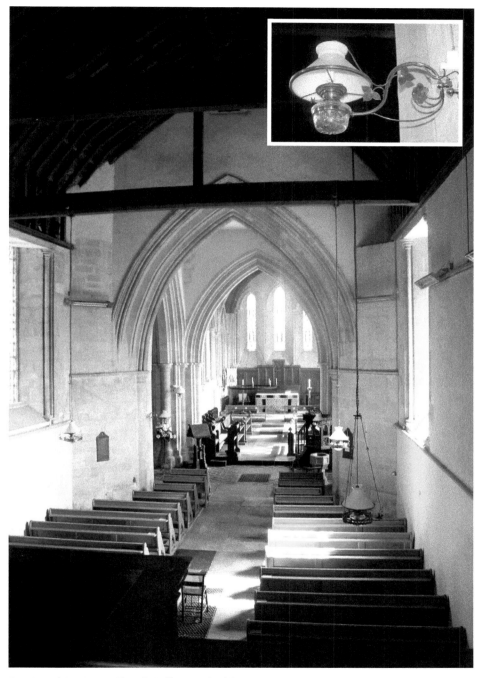

Interior of St Mary's Church, Uffington, looking east.

*Inset*: 'Betjeman' lamp.

The crossing is marked by strongly pointed arches, those on the west side effectively accommodated within huge block piers, designed to support the stone octagon and former spire above. The top storey of the tower replaced the fallen spire. The transept chapels project one bay, opening through beautifully moulded arches to curious pointed barrel vaults similar to that of the small porch in the south transept. The even more curious pointed windows with triangular heads were probably part of a late seventeenth-century restoration that also accounted for the eyebrowlike heavy hood moulds over the three lancets at the west end of the nave.

The two-storey south porch has an upper room for the priest, with a small window looking down into the nave. At ground level the entrance arch and the doorway to the nave have superb capitals in the stylised foliage style known as stiff-leaf, and the door itself has good, swirly ironwork of around 1300. On a more modern note, the brass lamps inside the church were rescued from threatened removal and wired for electricity after pressure from Sir John Betjeman, poet and churchwarden.

## 41. ST PETER AND ST PAUL'S CHURCH, WANTAGE

Wantage is an ancient town. The church is a large, stocky building just off the marketplace. It is cruciform, with a massive central tower built on huge crossing piers. The earliest parts of the standing structure date from the first half of the thirteenth century. The chancel and the side chapels overlapping it at the ends of both aisles are later, with Perpendicular mouldings, capitals and window tracery; but the remains of a roofline on the wall above the chancel arch, far too narrow for the existing building, represent the ghost of an earlier one.

The architecture, inside and out, is purposeful and chunky, and it feels Victorian. Some of the atmosphere must be owed to G. E. Street's restoration of 1857, but the church was lengthened by William Butterfield in 1877, whose west front has two windows and a central buttress, like Street's west front for St Simon and St Jude's Church, **Milton-under-Wychwood**. The ornate pulpit, made of stone, pink and black marble, and ironwork, with twisted barley-sugar columns and several kinds of medieval foliage capitals, is dated to 1857 and therefore thought to be the work of Street.

Yet the nave arcade, widely spaced, is early Gothic, with cylindrical piers, moulded capitals and bases and pointed chamfered arches. The only foliage capital of this period is at the back of the north-east crossing pier, a fine example of the style known as stiff-leaf, supported on a bundle of shafts. The arches into the crossing are very narrow by comparison with the nave arcade, and the crossing piers correspondingly big in support of the tower. This makes the chancel seem remote, and it is not surprising that the modern choir has been moved into the nave. But the chancel itself is not only screened by fifteenth-century timberwork but contains the original choir stalls of the same date – some with misericords featuring various birds and heraldry. On the north wall of the chancel is the tomb of Sir John Fitzwarin (d. 1361) and his wife, the finely carved effigies now exposed since the tomb canopy has been cut back to stubs on each side. High on the opposite wall is a touching monument to William Wilmot, who died as a child in 1684, and is shown here in the company of his grieving parents. This was made

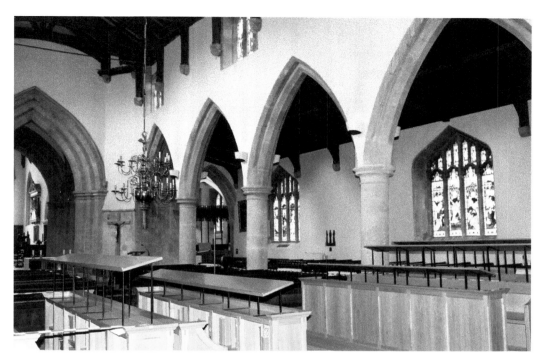

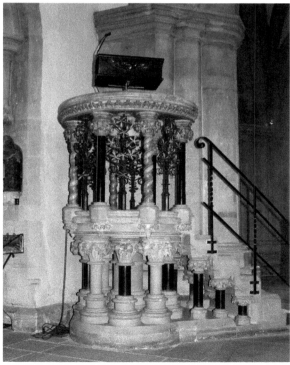

*Above*: Nave of St Peter and St Paul's Church, Wantage, looking south-east.

*Right*: The pulpit.

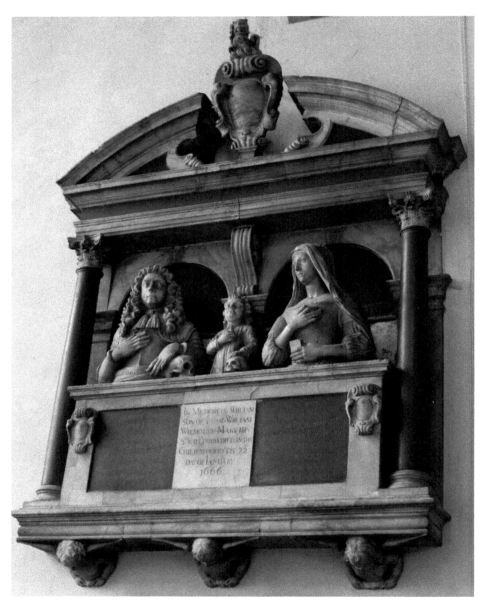

The Wilmot monument.

by William Byrd of Oxford, who restored the tomb of Lord and Lady Williams
in St Mary's, **Thame**, and one set of the Fettiplace monuments at St Mary's,
**Swinbrook.** In the Lady chapel is a stone plaque of Christ in Majesty with the
Evangelist symbols, carved in the 1970s by local sculptor Hydie Lloyd.

The windows throughout are fitted with excellent nineteenth-century stained
glass, which repays close attention.

## 42. ST BARTHOLOMEW'S CHURCH, YARNTON

You reach this church through much suburban development in Yarnton village, for Yarnton is situated close enough to Oxford for the latter's tentacles to encroach. Yet the church feels isolated and rural, and its east front presents a very striking aspect. A prominent chapel with large and impeccably Perpendicular windows dominates the approach; and only close inspection reveals that the much more modest projection on its north side is in fact the chancel of the church.

There are traces of Norman work, but the most obvious survival from that era is one of the two fonts, now decommissioned and kept in the Spencer chapel. A plain tub font, it was removed from the church at some unknown time, rediscovered and returned.

The church was rebuilt in the thirteenth century, and modernised with new windows a century or so later. The chancel arch has three orders set on a bundle of shafts with moulded capitals and bases. By 1611 the building was said to be in poor condition, and Sir Thomas Spencer, builder of the manor house next door, refurbished it in a fine antiquarian style, adding the south porch, the imposing west tower, and the Perpendicular Spencer chapel at the east end of the south aisle, thus rendering the chancel visually negligible. He installed a new pulpit, lectern and screens, of which the most distinguished is that leading into the Spencer chapel.

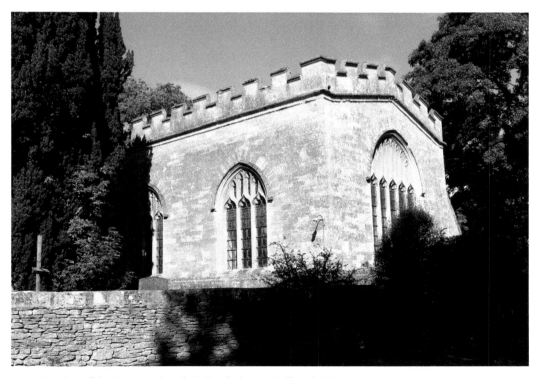

Exterior of the Spencer chapel, St Bartholomew's Church, Yarnton.

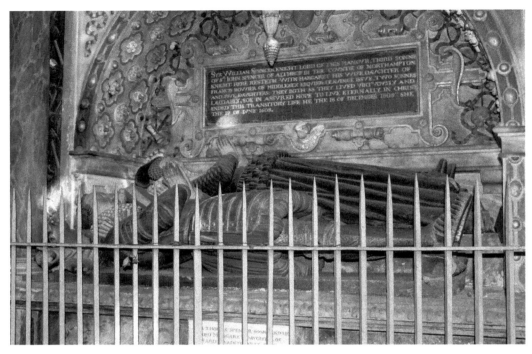

*Above*: Effigies of William and Margaret Spencer.

*Below*: Detail of the alabaster reredos, Christ carrying the Cross and the Virgin weeping over the dead Christ.

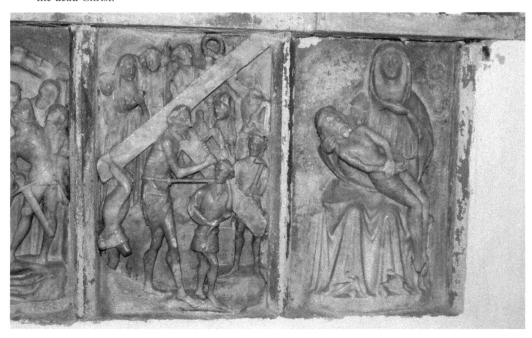

The Spencer chapel was fitted out with tombs, woodwork and armorial glass to create a complete monument to the Spencer family. Sir Thomas installed the easternmost tomb for his parents, Sir William (d. 1609) and his wife Margaret. The effigies lie under an arched canopy supported on Corinthian columns, with Margaret slightly lower than her husband; their sons and daughters are represented kneeling on the front of the tomb-chest. This lush monument is probably by the Netherlandish sculptor Jasper Hollemans, who made tombs for the family elsewhere. Following a centuries-long tradition of canopied wall tombs, it contrasts strongly with the memorial to the west, which was erected for Sir Thomas Spencer (d. 1684), his wife Jane and their children. White marble figures stand under a form of Palladian window against a black slate ground, Sir Thomas aggressive in the middle, his wife and son on a smaller scale making supplicating gestures either side. Seated figures of two daughters, flowers and urns make up the rest of the composition, which remained unfinished. Here all thoughts of traditional tomb design have vanished. There are other memorial tablets in the chapel; that to Charlotte, Duchess of Marlborough (d. 1850) expresses a softly sentimental Victorian hope of angelic intercession.

The church boasts decorations brought from elsewhere, including the fifteenth-century alabaster reredos, and the windows, full of stained-glass pieces, some possibly original to the church, others given from a private collection and much rearranged. Dates range from late medieval through the seventeenth century, with many pieces from the Netherlands. All reward contemplation.

# Acknowledgements

Most of the work on this book was carried out in the summer of 2020 in semi-lockdown conditions, and I am most grateful to all those people who ensured that I could gain access to churches that were open only at limited times. I am most grateful to the PCCs of Chalgrove and Spelsbury and to Chris Mitchell and Verna Wass for permission to use their photographs; and to Charles Baker at Chalgrove and Verna Wass at Cropredy for sharing with me their knowledge of those buildings and their paintings. My thanks also to the production team at Amberley Publishing.